GORDON PARKS

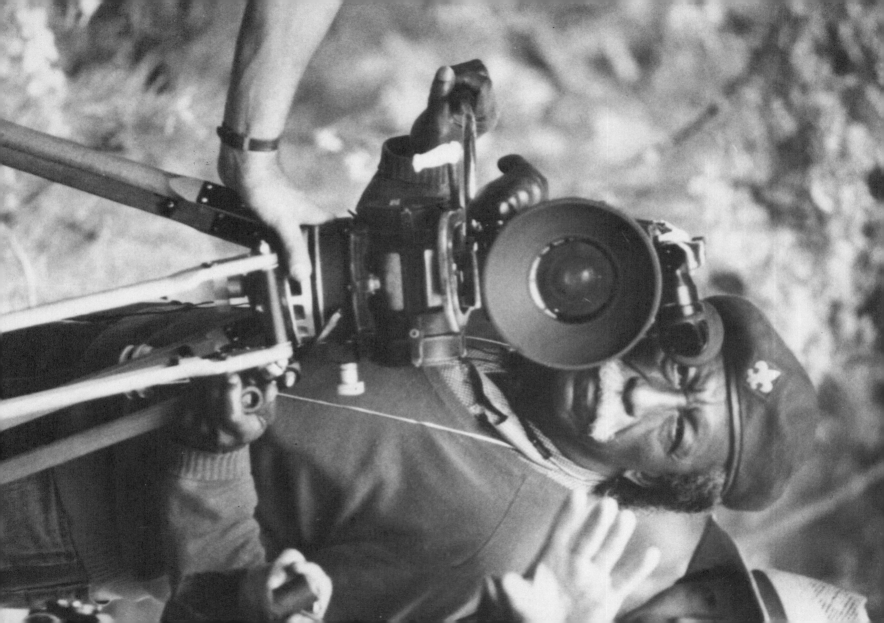

GORDON PARKS

Skip Berry

Senior Consulting Editor

Nathan Irvin Huggins

Director

W. E. B. Du Bois Institute for Afro-American Research
Harvard University

CHELSEA HOUSE PUBLISHERS

New York Philadelphia

180126

Chelsea House Publishers

Editor-in-Chief Remmel Nunn
Managing Editor Karyn Gullen Browne
Copy Chief Juliann Barbato
Picture Editor Adrian G. Allen
Art Director Maria Epes
Deputy Copy Chief Mark Rifkin
Assistant Art Director Loraine Machlin
Manufacturing Manager Gerald Levine
Systems Manager Rachel Vigier
Production Manager Joseph Romano
Production Coordinator Marie Claire Cebrián

Black Americans of Achievement

Senior Editor Richard Rennert

Staff for GORDON PARKS

Associate Editor Kate Barrett
Editorial Assistant Nicole Claro
Picture Researcher Vicky Haluska
Designer Ghila Krajzman
Cover Illustration Gil Ashby

3 5 7 9 8 6 4 2

Library of Congress Cataloging-in-Publication Data

Berry, Skip
 Gordon Parks, photographer/by Skip Berry.
 p. cm.—(Black Americans of achievement)
 Includes bibliographical references.
 ISBN 1-55546-604-4
 0-7910-0248-9 (pbk.)
 1. Parks, Gordon, 1912– . 2. Afro-American photographers—
United States—Biography. 1. Title.
II. Series.
TR140.P35J35 1990
770'.92—dc20 90-1479
[B] CIP

*Frontispiece: Gordon Parks and
his assistants prepare for a 1983
shoot in Savannah, Georgia.*

CONTENTS

❧

BLACK AMERICANS OF ACHIEVEMENT

RALPH ABERNATHY
civil rights leader

MUHAMMAD ALI
heavyweight champion

RICHARD ALLEN
religious leader and social activist

LOUIS ARMSTRONG
musician

ARTHUR ASHE
tennis great

JOSEPHINE BAKER
entertainer

JAMES BALDWIN
author

BENJAMIN BANNEKER
scientist and mathematician

AMIRI BARAKA
poet and playwright

COUNT BASIE
bandleader and composer

ROMARE BEARDEN
artist

JAMES BECKWOURTH
frontiersman

MARY MCLEOD BETHUNE
educator

BLANCHE BRUCE
politician

RALPH BUNCHE
diplomat

GEORGE WASHINGTON CARVER
botanist

CHARLES CHESNUTT
author

BILL COSBY
entertainer

PAUL CUFFE
merchant and abolitionist

FATHER DIVINE
religious leader

FREDERICK DOUGLASS
abolitionist editor

CHARLES DREW
physician

W.E.B. DU BOIS
scholar and activist

KATHERINE DUNHAM
dancer and choreographer

PAUL LAURENCE DUNBAR
poet

MARIAN WRIGHT EDELMAN
civil rights leader and lawyer

DUKE ELLINGTON
bandleader and composer

JULIUS ERVING
basketball great

JAMES FARMER
civil rights leader

ELLA FITZGERALD
singer

MARCUS GARVEY
black-nationalist leader

DIZZY GILLESPIE
musician

PRINCE HALL
social reformer

W. C. HANDY
father of the blues

WILLIAM HASTIE
educator and politician

MATTHEW HENSON
explorer

CHESTER HIMES
author

BILLIE HOLIDAY
singer

JOHN HOPE
educator

LENA HORNE
entertainer

LANGSTON HUGHES
poet

ZORA NEALE HURSTON
author

JESSE JACKSON
civil rights leader and politician

JACK JOHNSON
heavyweight champion

JAMES WELDON JOHNSON
author

SCOTT JOPLIN
composer

BARBARA JORDAN
politician

MARTIN LUTHER KING, JR.
civil rights leader

ALAIN LOCKE
scholar and educator

JOE LOUIS
heavyweight champion

RONALD MCNAIR
astronaut

MALCOLM X
militant black leader

THURGOOD MARSHALL
Supreme Court justice

ELIJAH MUHAMMAD
religious leader

JESSE OWENS
champion athlete

CHARLIE PARKER
musician

GORDON PARKS
photographer

SIDNEY POITIER
actor

ADAM CLAYTON POWELL, JR.
political leader

LEONTYNE PRICE
opera singer

A. PHILIP RANDOLPH
labor leader

PAUL ROBESON
singer and actor

JACKIE ROBINSON
baseball great

BILL RUSSELL
basketball great

JOHN RUSSWURM
publisher

SOJOURNER TRUTH
antislavery activist

HARRIET TUBMAN
antislavery activist

NAT TURNER
slave revolt leader

DENMARK VESEY
slave revolt leader

MADAM C. J. WALKER
entrepreneur

BOOKER T. WASHINGTON
educator

HAROLD WASHINGTON
politician

WALTER WHITE
civil rights leader and author

RICHARD WRIGHT
author

ON
ACHIEVEMENT

❧

Coretta Scott King

BEFORE YOU BEGIN this book, I hope you will ask yourself what the word excellence means to you. I think that it's a question we should all ask, and keep asking as we grow older and change. Because the truest answer to it should never change. When you think of excellence, perhaps you think of success at work; or of becoming wealthy; or meeting the right person, getting married, and having a good family life.

Those important goals are worth striving for, but there is a better way to look at excellence. As Martin Luther King, Jr., said in one of his last sermons, "I want you to be first in love. I want you to be first in moral excellence. I want you to be first in generosity. If you want to be important, wonderful. If you want to be great, wonderful. But recognize that he who is greatest among you shall be your servant."

My husband, Martin Luther King, Jr., knew that the true meaning of achievement is service. When I met him, in 1952, he was already ordained as a Baptist preacher and was working towards a doctoral degree at Boston University. I was studying at the New England Conservatory and dreamed of accomplishments in music. We married a year later, and after I graduated the following year we moved to Montgomery, Alabama. We didn't know it then, but our notions of achievement were about to undergo a dramatic change.

You may have read or heard about what happened next. What began with the boycott of a local bus line grew into a national movement, and by the time he was assassinated in 1968 my husband had fashioned a black movement powerful enough to shatter forever the practice of racial segregation. What you may not have read about is where he got his method for resisting injustice without compromising his religious beliefs.

He adopted the strategy of nonviolence from a man of a different race, who lived in a distant country, and even practiced a different religion. The man was Mahatma Gandhi, the great leader of India, who devoted his life to serving humanity in the spirit of love and nonviolence. It was in these principles that Martin discovered his method for social reform. More than anything else, those two principles were the key to his achievements.

This book is about black Americans who served society through the excellence of their achievements. It forms a part of the rich history of black men and women in America—a history of stunning accomplishments in every field of human endeavor, from literature and art to science, industry, education, diplomacy, athletics, jurisprudence, even polar exploration.

Not all of the people in this history had the same ideals, but I think you will find something that all of them have in common. Like Martin Luther King, Jr., they all decided to become "drum majors" and serve humanity. In that principle—whether it was expressed in books, inventions, or song—they found something outside themselves to use as a goal and a guide. Something that showed them a way to serve others, instead of living only for themselves.

Reading the stories of these courageous men and women not only helps us discover the principles that we will use to guide our own lives but also teaches us about our black heritage and about America itself. It is crucial for us to know the heroes and heroines of our history and to realize that the price we paid in our struggle for equality in America was dear. But we must also understand that we have gotten as far as we have partly because America's democratic system and ideals made it possible.

We are still struggling with racism and prejudice. But the great men and women in this series are a tribute to the spirit of our democratic ideals and the system in which they have flourished. And that makes their stories special and worth knowing.

GORDON PARKS

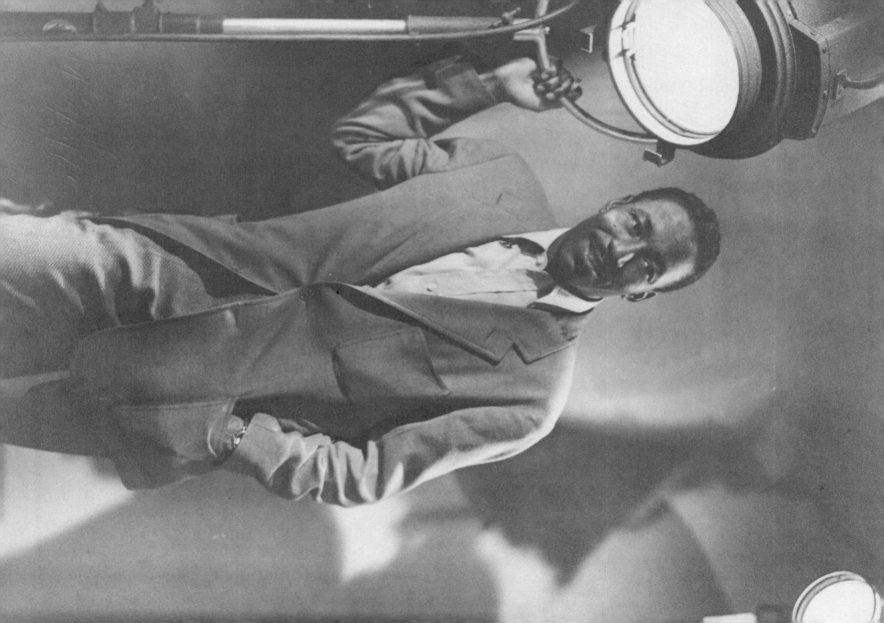

1

THE FACE
OF AMERICA

❦

I T WAS A cold, clear January morning in 1942 when Gordon Parks stepped off the train in Washington, D.C.'s Union Station. Bags in tow, the 29-year-old photographer hailed a cab, his skin tingling with excitement at being in the nation's capital for the first time. He wanted to see the places where great statesmen had delivered the speeches and drawn up the legislation that had shaped the country's history. He wanted to walk where presidents had walked. But most of all, Parks wanted to take great pictures. After all, it was his skill with a camera that had earned him the chance to come to Washington.

Parks was still elated at having been awarded a fellowship by the Julius Rosenwald Fund, for it provided him with money for an entire year to study photography in the manner and place of his choice. The fellowship had enabled Parks to transform a long-standing dream into reality: to work for the highly regarded photography division of the Farm Security Administration (FSA), a branch of the federal government set up by President Franklin Roosevelt to help farmers suffering from the effects of the Great Depression. Photographers employed by the FSA were responsible for documenting life in America during the depression.

Gordon Parks, who rose from an impoverished childhood in Kansas to international celebrity as a photographer, refused to bow to racial prejudice or convention. Learning to channel his anger and insisting on his rights as a free man, he became a best-selling author and a highly respected composer and painter as well as a legendary photographer.

After dropping off his luggage at the rooming house where he would be staying, Parks hopped a streetcar and headed off to make history. He was the first—and as it turned out, the only—black photographer ever to work for the FSA.

On that January morning, Parks was exhilarated by the prospect of working for the FSA, not by the fact that he would be the initial black on its staff. A few years earlier, while working as a waiter in railroad dining cars, he had got his first inkling of the power of fine photography by studying magazine photos shot by such well-known FSA photographers as Jack Delano, Dorothea Lange, and Walker Evans. Their work had inspired his decision to make photography his career.

Parks got off the streetcar at the intersection of Fourteenth and Independence avenues. He stood for a moment in front of the large redbrick building that housed the FSA, feeling the weight of the camera bag slung over his shoulder. This was the place he had left Chicago to find. Then, taking a deep breath, he pulled the front door open and went in search of the photography division.

As he wandered the corridors, Parks anticipated stepping into a room filled with photographs and fellowship. But when he finally found the door he was looking for, it opened instead into a room filled with nondescript office furniture and rows of file cabinets. There was not a photograph or a fellow photographer in sight. What was more, the windows were filthy.

"Welcome to Washington," cried a white-haired, bespectacled figure who bounded out of a nearby office, hand extended. "I'm Roy."

This was the man Parks had come to meet, the man who had invited the young photographer to Washington when he had expressed a desire to work for the FSA during his fellowship year. A legend among photographers, Roy Emerson Stryker had run the FSA's photography division since its formation.

Though not a photographer himself, he had an unerring eye and a keen sense of the emotional impact of photos.

Under Stryker's guidance, many of the country's best photographers had contributed vivid, memorable images to the FSA's documentation of life during the depression years. By 1942, Stryker had compiled files full of some of the most important photographs in American history. Indeed, the FSA's photo collection was both a searing indictment of the greed that had laid land and lives to waste and a powerful testament to human misery and dignity in a trying time.

Parks had come to Washington to learn as much as he could about photography from Stryker; but the first thing his new teacher did was take his cameras away from him. "You won't be needing those for a few days," said Stryker, locking the battered Speed Graphic and the Rolleiflex in his office closet. Then he instructed his newest staff member to spend some time getting acquainted with the nation's capital. "Go to a picture show, the department stores, eat in the restaurants and drugstores," Stryker said. "Get to know this place. Let me know how you've made out in a couple of days."

Parks agreed to follow his new boss's orders, even though he thought they were a bit unusual. After all, he had come to Washington to learn everything he could, and if walking around the city doing what he pleased was Stryker's idea of a training exercise, Parks was all for it. Besides, he had been looking forward to exploring the city.

Parks decided to begin his day on the town by heading downtown for breakfast. Stopping at a drugstore, he went inside and sat on a stool at the counter, only to be accosted by an angry waiter. "Get off that stool," the man said. "Don't you know colored people can't eat in here? Go round to the back if you want something." Everyone in the place stared at Parks as he retreated to the sidewalk.

Perplexed by what had just happened, Parks set off down the street to try his luck somewhere else. He stopped at a hot dog stand, where the white-coated vendor served him, albeit reluctantly and rudely. When Parks tried to buy a ticket at a movie theater, something he had done in plenty of other cities around the country, he was refused admission. And when he entered a department store in search of an overcoat, none of its many idle salesclerks would wait on him. In 1942, racism seemed to be everywhere in Washington, D.C., from the corner drugstore all the way, as he eventually learned, to the halls of Congress, where southern congressmen were unhappy with Stryker for adding a black photographer to his staff.

Parks was both angered at and bewildered by the attitudes he encountered. Racial discrimination was not a new experience for him: He had been taunted and cursed at in towns and cities throughout the country—from his childhood home of Fort Scott, Kansas, to the streets of Chicago and New York. But finding it so blatantly displayed in Washington, D.C., was something he had not expected.

After a few frustrating hours, Parks returned to Stryker's office and demanded to have his cameras back. He would show the world, he declared, what the capital of the United States of America was *really* like.

Rather than give Parks his equipment, Stryker asked him to sit down and talk about his morning on the town. Parks poured out his disgust at how he was treated throughout the city.

"Whatever else it may be, this is a southern city," Stryker said after the angry young photographer had finished talking. "Whether you ignore it or tolerate it is up to you. I purposely sent you out this morning so that you can see just what you're up against."

Stryker went on to tell Parks that as the only black photographer in the FSA, he was going to en-

Parks shot this wartime picture of Union Station soon after his 1942 arrival in Washington, D.C. Excited about his trip to the nation's capital, the 29-year-old black Kansan was shocked by the events of his first day there: He was refused service at a lunch counter, ignored by white clerks in a store, and rudely turned away from a movie theater.

Roy Stryker, head of the Farm Security Administration's photography division, sits for a Parks portrait in 1942. "There was something boyish, something fatherly, something tyrannical, something kind and good about him," said Parks about Stryker, who became the young photographer's mentor and good friend.

counter a variety of attitudes within the agency, especially among the lab technicians who processed the photographers' film and developed their prints. All of them are good technicians, Stryker said, but they are also all southerners. "I can't predict what their attitudes will be toward you," he told Parks, "and I warn you I'm not going to try to influence them one way or the other. It's completely up to you." He then escorted Parks throughout the FSA building, introducing him to various employees. Their reactions ranged from smiles and handshakes to abrupt nods and cold shoulders.

After the tour, Stryker gave Parks his first assignment. He asked him to write out his plan for fighting discrimination. You cannot just take a picture of a white salesman, waiter, or ticket seller and label him prejudiced, Stryker told him. After all, a racist looks like anyone else. The camera is only able to expose the true face of America by showing those people who have suffered at the hands of others. Your images will have an emotional impact only if you, the photographer, bring your own feelings to your pictures.

Stryker told Parks to put his experiences into words, then find ways to turn what he had written into pictures that expressed those experiences. "Think in terms of images and words," Stryker said. "They can be mighty powerful when they are fitted together properly." To help Parks get started, Stryker threw open a file drawer and told him to study the work of other FSA photographers.

Parks spent the next few weeks sifting through hundreds of photos, steeping himself in powerful images of the Dust Bowl, a region in the central United States devastated by intense drought in 1936. Its rural inhabitants, already gravely affected by the depression that began in late 1929, lost all sources of income from their farms. Battered by poverty, thousands of displaced Americans drifted down the Dust Bowl's

highways in search of new lives. Along the way, many of them came within camera range, and their struggles to overcome the grim realities of the time became a central part of the FSA's record of the 1930s.

As moving as the photographs were, Parks found the written accounts that accompanied them equally provocative. Together, the photographs and texts formed a clear and detailed record of the period, dredging up all the human misery that resulted from environmental and economic hardship. Parks began to see just how potent the combination of well-conceived photos and a well-written essay could be. To portray racial discrimination, he had to do more than simply point a camera at the problem.

Parks got the chance to put into practice what he had just learned sooner than he expected. One evening, Stryker suggested that Parks strike up a conversation with the thin, gray-haired black woman who cleaned the FSA building. Parks shrugged at the suggestion, believing it to be another of his boss's odd notions; yet he decided to give it a try. He searched the woman out, then spent an awkward few minutes trying to make small talk with her.

Gradually, the woman began to discuss her life in earnest. Her mother had died when she was young, and her father had been lynched. Her husband had been shot 2 days before the birth of their daughter, who had died at the age of 18, just 2 weeks after giving birth to her second child. This woman was now trying to raise her two small grandchildren, one of whom was paralyzed, on the meager salary she earned mopping floors.

Unable to offer the woman any immediate help, Parks responded the only way he could think of at the time. "Can I photograph you?" he asked.

"I don't mind," she replied.

The result was a photo Parks later called "unsubtle," but one that ranks among his best-known

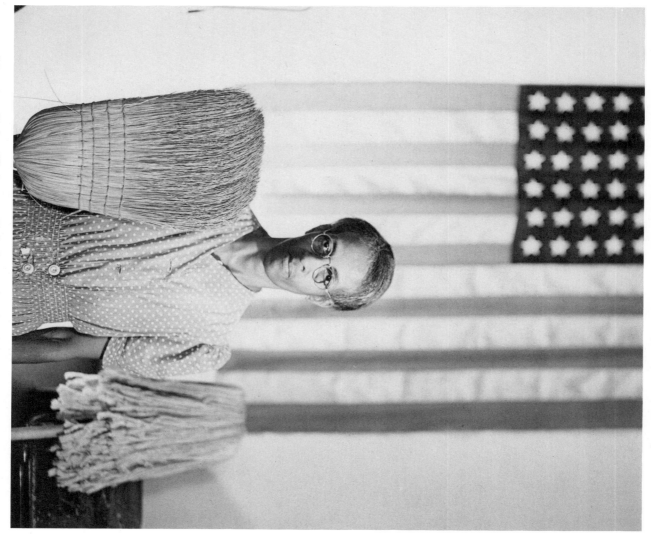

"American Gothic, Washington, D.C.," one of Parks's best-known photographs, shows a cleaning woman with the tools of her trade. Parks later made a series of such portraits, impressing his new boss. "This woman has done you a great service," said Roy Stryker.

works. Entitled "American Gothic, Washington, D.C.," it depicts the sharp-featured cleaning woman standing against a background of the American flag, a broom in one hand and a mop in the other.

During the following month, Parks continued to photograph the same woman in a variety of settings, including her home and her church. At the end of the month, he brought all of the photos to Stryker and spread them out for him to examine. Parks heard what he had already figured out for himself. "This woman has done you a great service," Stryker said. "I hope you understand this."

Parks did. Thanks to the cleaning woman, he was beginning to understand how demanding documentary photography could be. Stryker had set high standards for FSA photographers: He expected them not only to get involved with their subjects but to have empathy for the people whose lives they were documenting. Yet a photographer should not let emotions interfere with the ability to present the facts of the story.

Parks also realized during his first month in Washington, D.C., that the demanding process of documentary photography was going to be even more difficult because he was black. Since its earliest days, photography had been a profession pursued predominantly by whites. No one was waiting with bated breath for the first great black photographer to appear.

Yet Parks had not forgotten what his mother had repeatedly told him while he was growing up in Kansas: "If a white boy can do it, so can you. Don't ever come home telling me you can't do this or that because you're black." 🔌

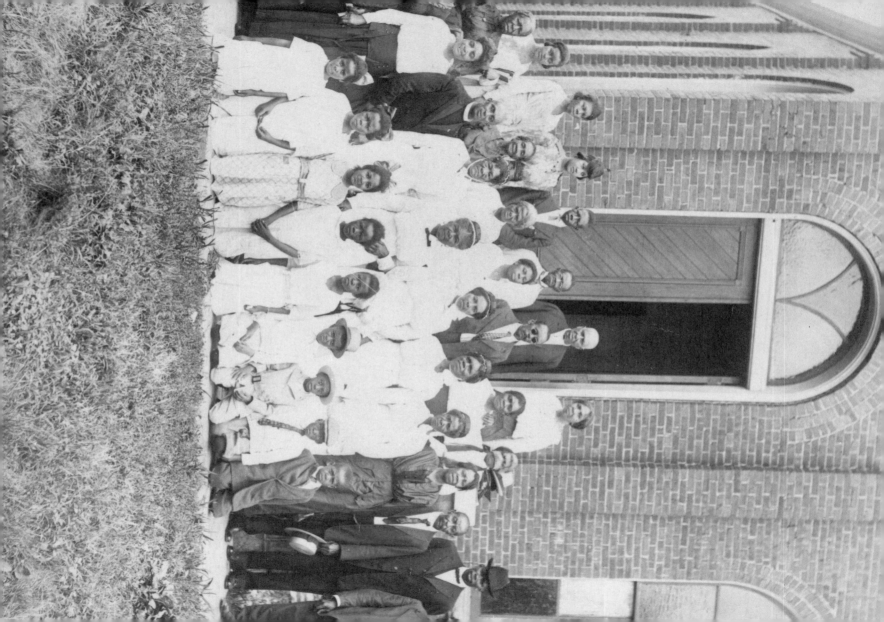

2

"A MATTER OF SURVIVAL"

GORDON PARKS WAS born on November 30, 1912, in a small house in the black section of Fort Scott, Kansas. The youngest of Sarah Ross and Andrew Jackson Parks's 15 children, he was stillborn, according to family lore. He came to life only after the physician who was present at Parks's birth, a man named Dr. Gordon, placed him in a tub of cold water. The bracing water revived his heartbeat and earned Dr. Gordon a namesake.

In his autobiography *A Choice of Weapons*, Parks remembered his boyhood in the small prairie town as a time of relative ease, thanks to the fertile Kansas land. "We were poor," he wrote, "though I did not know it at the time; the rich soil surrounding our clapboard house had yielded the food for the family."

Andrew Parks fed and clothed his large family by working as a farmer and performing odd jobs around town. He was a quiet man whose conversations with his youngest son were limited to such clipped salutations and commands as "Mornin', boy," "Git your chores done, boy," and, at the end of the day, "Good night, boy." Parks later said that in his entire life his father did not speak more than a thousand words to him.

The Parks family gathers for a group portrait with other members of their Fort Scott Methodist church. Gordon kneels in front, third from the right; his mother, Sarah, stands to the left of his blind uncle (wearing dark glasses); his father, Andrew, stands fifth from the right. "Momma and Poppa had filled us with love and a staunch Methodist religion," Parks recalled later. "The love of this family eased the burden of being black."

Yet Gordon revered his father for the strength and generosity that came across in his gestures, such as when he would reach into the pocket of his jeans and wordlessly hand his son a hard-earned nickel or dime. Parks later said his father was so big of heart that "it took a thousand men to carry him to his grave."

Sarah Parks possessed a similar strength of character, which belied her fragile appearance. She was small and wiry, with a faint pink scar on her left temple, the result of her having once been struck by lightning. She also had a gap in her teeth—the sign of a liar, according to Gordon's third-grade teacher. Yet Sarah valued honesty and righteousness above all else. She was a devoted churchgoer who expected everyone in the Parks family to attend Sunday school and church services, as well as Wednesday evening prayer meetings, at the local Methodist church.

Together, Andrew and Sarah Parks provided their children with strong family bonds and taught them the value of honor, education, equality, and honesty—qualities that would help them cope with being black in the face of widespread racism. "The love of this family," Parks remembered, "eased the burden of being black."

But his parents' love did not remove the burden entirely. The town in which Parks grew up was racially segregated, and discrimination pervaded its movie theaters and soda fountains as well as its schools and public facilities. Fort Scott was the kind of place where white children taunted black children in the streets. It was a community where young black men lived with the constant fear of being beaten or shot.

Friendship between a black child and a white one in Fort Scott was bound to be tainted by bigotry, as Gordon discovered when he was 12 years old. That summer, one of his cousins, a fair-skinned girl with

light red hair, came for a visit. While the two of them were walking down the street one afternoon, a trio of white youths confronted them. Believing that the girl was white, one of the boys asked her, "Where you going with that nigger, blondie?" Then the youths attacked Gordon, hitting and kicking him, until a white friend happened by and helped fend them off. Later, when Gordon described to his friend the circumstances that had led to the attack, the boy said, with unwitting bigotry, "The dunces. Hell, I knowed she was a nigger all the time."

Despite his encounters with racism, Gordon's boyhood was, on the whole, filled with simple plea-

Sarah Ross Parks armed her son Gordon with solid values to combat life's injustices: "My mother," he said, "had freed me from the curse of inferiority long before she died by not allowing me to take refuge in the excuse that I had been born black."

sures. When he was not attending school, he could often be found playing basketball, fishing or swimming, chasing butterflies and fireflies, or lying on the lush green Kansas grass studying the stars on a summer night. Like many youths, he did not realize how hard his parents had to work at providing him with the things he took for granted: clothing, food, and shelter.

In 1928, however, Gordon left these simple pleasures behind and was forced to confront the extent of the sacrifices his mother had made for her family. One afternoon, he stood in the yard watching her walk home from her job as a domestic on the white

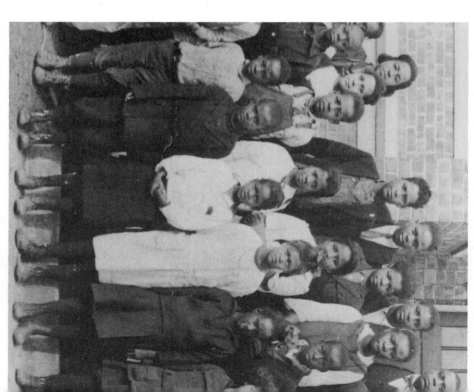

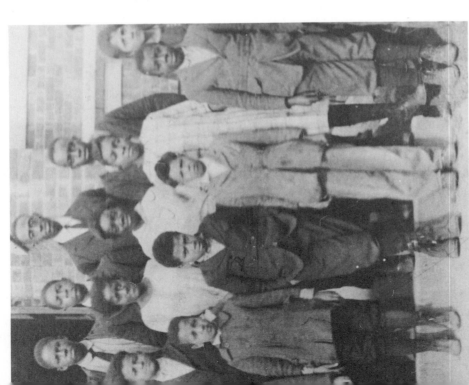

Eleven-year-old Gordon Parks (second row, fifth from left) lines up with fellow students outside Fort Scott's all-black Plaza School in 1923. "Kansans sent us to a segregated school," Parks recalled later, "but by the time we entered high school, they mixed us up, possibly because they didn't have enough money to build a black high school."

side of town. As usual, she carried a market basket under one arm. But something was not right. Instead of her usual energetic stride, Sarah Parks was trudging along, her gingham skirt dragging in the dust. She clutched a blood-flecked handkerchief in her free hand.

"What's the matter, Momma?" cried Gordon, rushing to help her into the house. He eased her into a chair, his alarm increasing at the sight of her fatigue. "What's the matter?"

Sarah told her youngest son that it was time for him to go to St. Paul, Minnesota, and live with his sister Maggie Lee and her husband. "It's a better world

up there in the North," she said. "Color won't work so hard against you." She clutched her handkerchief in her bony hand. "Do right and don't get in trouble, and make a good man of yourself."

That said, Sarah told Gordon to go out to the fields and find his father. "I'm awful tired," she sighed, her head sagging back to rest against the chair.

By the time Gordon returned home with his father, Sarah Parks had fallen from the chair and was unconscious. Within a few weeks, she was dead.

"After my mother died, it was a matter of survival," Parks said later. "I had to learn fast. . . . I had to do it on plain dreams, guts and hope."

It was not until his mother lay dying that Gordon realized that she had worked herself to death. The long hours that she had spent scrubbing and cleaning for other families while raising a large family of her own had gradually worn down the frail Sarah Parks and had helped kill her.

Gordon had long suffered from an overwhelming fear of death. When he was nine years old, he had sat alone one evening in the black section of a Fort Scott movie theater, watching *The Phantom of the Opera*, starring Lon Chaney. When the Phantom suddenly pulled off his mask and a death skull filled the screen, the young Parks fled the theater in panic. "I'm going to die!" he screamed. "I'm going to die!" He ran all the way into his mother's comforting arms.

Two years later, a policeman paid Gordon and one of his friends 50 cents each to search for the body of a gambler who had fallen into a river after the officer had shot him. The two boys swam through the murky water, using ice hooks to probe for the body. They found the man and towed his body ashore to collect their pay, but the memory of the waterlogged corpse haunted Gordon's dreams for months afterward.

By the time he was 16 years old, Gordon had not

yet overcome his fear of death. But when his mother died, he resolved to master it. The night before her funeral, Gordon crept into his family's parlor, where her coffin was on display, and forced himself to sleep on the floor next to the corpse. The following afternoon, after watching his mother's coffin lowered into a freshly dug grave, he kissed his father on the cheek, picked up a cardboard suitcase, and boarded a northbound train. He was going to live with his sister Maggie Lee.

According to his mother, the North was the best place in America for blacks to live; there was supposedly less racial discrimination in the North than anywhere else in the country. "Make a man of yourself up there," Sarah Parks had advised him shortly before she died. As it turned out, he was forced to become a man up North sooner than he would have wished.

Maggie Lee had married a railroad porter, a big man with little use for his wife's youngest brother. Gordon spent his first evening in St. Paul being told by his brother-in-law that he had to follow a set of strict rules. That night, while he was lying in his new bed, Gordon had a premonition that he would not be living with his sister and her husband for long.

Nevertheless, Gordon did all he could to make his new life work. He enrolled in Mechanics Arts High School, got a job busing tables in a diner, and joined the Diplomats Club, a social club for young black men. He also played basketball. Having learned to play the sport on a court that used small barrel rims for hoops, Gordon had an exceptionally sure eye and a sweet touch when shooting at regulation-sized baskets; he was an instant success on the Diplomats' team. As the winter approached, he seemed fully adjusted to his new life.

One evening in December, as Gordon was leaving the house for a club meeting, his brother-in-law growled, "Where you going, boy?"

"To a club meeting," Gordon replied. "You ain't goin' no place. You been out two nights in a row."

When Gordon tried to explain that club members were meeting one final time to plan a Christmas party, his brother-in-law blocked his way and ordered Gordon back to his room. Maggie Lee stepped between them to prevent her husband from striking Gordon, but the powerful train porter shoved her against the wall. Gordon rushed to his sister's defense and started punching his brother-in-law. It was no contest,

though, and Gordon soon found himself standing outside in the bitter cold while his enraged brother-in-law pitched Gordon's belongings out a second-floor window. As the wind whipped along the snow-covered streets, the shivering teenager turned up his collar and headed off in search of shelter.

Too ashamed to show up at his club meeting with a suitcase and no place to call home, Gordon wandered into a nearby pool hall, where he stood by the radiator to thaw his numb fingers and toes and ponder his predicament. It was a Friday night, and the diner

Parks's childhood in Fort Scott (shown here, in the 1920s) left him with mixed memories: He recalled not only the sense of security provided by his tightly knit, loving family but also the anxiety produced by the midwestern town's racial intolerance. Fort Scott, said Parks in 1973, "is where my mother, through love and pain, gave life to me. It is where she, my father, brothers and sisters lie, awaiting the resurrection, in a segregated burial ground."

where he worked was closed until Monday. His high school was closed for the Christmas holidays. Because he was new in town he did not have many close friends to whom he could turn. All he had in his pocket was a total of $2.50, so he could not afford a place to stay. When the pool hall closed for the night, he was literally going to be out in the cold.

With no other options, Gordon made the trolley that ran between St. Paul and Minneapolis his home for the next few weeks. The fare was cheap, and the cars were reasonably warm. He ate one meal a day at the diner where he worked; for the rest of his meals, he used the six dollars a week he earned in salary to buy hot dogs and root beer.

When Gordon was not working, he searched in vain for a more lucrative job. Yet everyone he talked to had a reason for turning him down. Depressed and nearly broke, he continued to ride the trolleys, growing more desperate with each passing day.

One dawn, after another night of restless sleep aboard a trolley, Gordon awoke with a start. The conductor was shaking him, telling him they had reached the end of the trolley line. In the man's hand, Gordon noticed, was a wad of bills.

Gordon had a switchblade knife in his coat pocket. As the conductor turned away, Gordon pulled out the knife and clicked open the blade. "Conductor!" he blurted out.

"Yes," said the conductor as he turned around. He saw the knife in Gordon's trembling hand.

"Conductor," Gordon stammered, "would you give me a dollar for this knife? I'm hungry and I don't have any place to stay."

The conductor told Gordon to keep the knife and offered to buy him a meal instead.

Deeply ashamed that he had nearly threatened the man for his money, Gordon refused the offer and jumped off the trolley before the conductor could

convince him to accept a couple of dollars. He fled down an alley, crazy with fear at how close he had come to ignoring everything his parents had ever taught him.

Gordon spent the rest of the early morning hours walking along the city's streets, peering into store windows filled with Christmas hams and turkeys and conjuring up memories of his family home in Fort Scott, which he knew would be warmed by a potbellied stove and filled with the aroma of roast chicken, corn bread, and freshly baked rolls. He found it hard to refrain from smashing through the glass that kept him from the food on the other side of the windows.

Then Gordon remembered the advice that his brother Leroy had delivered a few years earlier, as he lay dying of an incurable disease. "You can't whip the world," Leroy had said. "It's too big. If you're going to fight it, use your brain." Wandering the frozen sidewalks of St. Paul, Gordon decided to heed his brother's words.

"You'll see!" Gordon shouted to his brother-in-law a few days later, when he spotted him on the opposite sidewalk. "I'll make it! You'll see!"

His brother-in-law spat in the snow and walked away. ❧

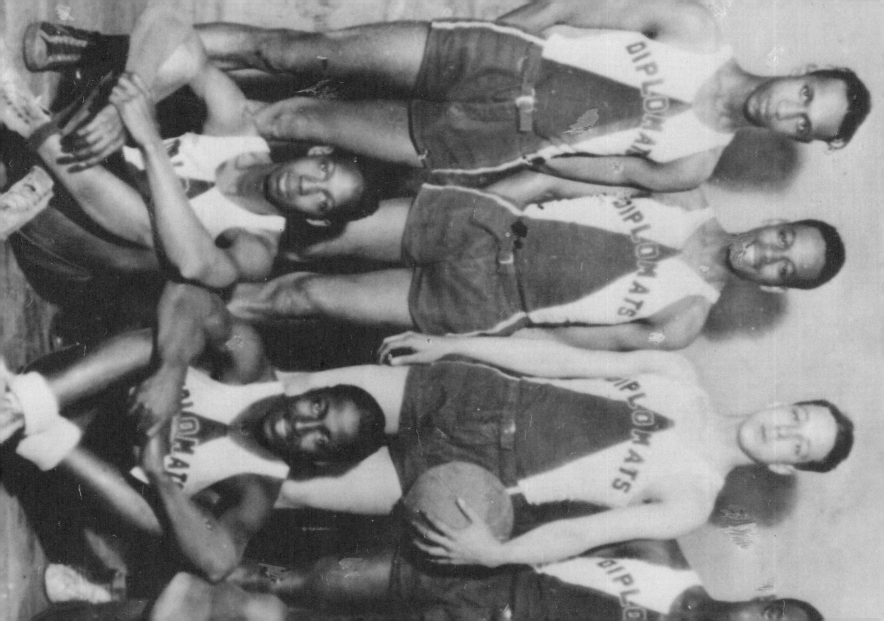

3

FROM BAD TIMES
TO WORSE

O N CHRISTMAS EVE in 1928, Gordon Parks was sweeping the floor of the diner where he worked when four policemen walked in and started shoving around both him and the owner, a skinny, bad-tempered man named Freddie Connors. "Where's the stuff?" demanded the cops.

Although the 16-year-old Parks had no idea what they were talking about, Connors finally led everyone to the basement room he had warned Parks never to enter. When the owner unlocked the door, it swung open to reveal a room filled with jewelry, furs, paint-ings, suits, radios, and automobile tires. As the police had suspected, Connors was a "fence," a man who trafficked in stolen goods he had bought from thieves.

Staring blankly as the police handcuffed his em-ployer, Parks suddenly grabbed at Connors's arm. "How about my week's pay?" the teenager asked.

"I got troubles," Connors said, "you got troubles."

Suddenly finding himself out of work, Parks hunched his shoulders against the cold as he watched the paddy wagon pull away. There was nothing for him to do now but head for the pool hall where he had taken shelter the night he had fought with his

Parks (seated at center) and his fellow Diplomats get together for a team portrait in St. Paul. The lonely young man from Fort Scott was cheered by the companionship of his big-city teammates and by their praise for his outstanding efforts on the basketball court.

brother-in-law; it had become his daily refuge. Every weekday morning when he got off the chilly trolley, Parks would stop at the pool hall to warm himself up before going to school. In the evenings, after he finished washing dishes at the diner, he would do his homework propped up beside the hall's radiator.

Tee Vernon was the hall's rack man and bouncer; he used his huge belly and hard head to keep unruly customers in line. But he could be as generous as he was tough. Seeing how hungry and poor Parks was, Vernon often gave the youth sandwiches or shot pool with him for a dime a game.

Even before Connors was arrested, Parks had told Vernon he needed a better job than the one he had at the diner. "If only I could get a job playing piano," he had said.

"How long've you been playing?" Vernon had asked.

"As long as I can remember," Parks had replied. Actually, he had been plinking around on the piano since the age of seven. He was standing in a cornfield one summer afternoon, eating mulberries, watching clouds drift across the blue Kansas sky, and creating the sounds of violins, horns, and drums in his head. Running home, he immediately started banging on the keys of the family piano, trying to reproduce the music he had invented. He was too young and untrained to re-create the sounds he had imagined; yet the experience helped open up the world of music to him. From that moment on, Parks played the piano whenever he got the chance.

Vernon had told Parks he would be on the lookout for any jobs that might come up, and that Christmas Eve he proved to be true to his word. When Parks walked into the pool hall, Vernon introduced him to a tall, well-dressed black man. "This is Jimmy," the bouncer said. "He's from Pope's over in Minneapolis, and he needs a piano player. You interested?"

"I don't know if I'm good enough," Parks answered.

"You play the blues?" Jimmy asked.

Parks agreed to try his hand at playing blues piano at Pope's for two dollars a night plus tips, starting that very night.

Pope's turned out to be a bordello in Minneapolis's red-light district. The management paid Parks to entertain the customers and the prostitutes who worked in the house. He was accompanied by an albino drummer named Red, who was not any better at keeping time than Parks was at hitting all the right keys. But Pope's clients were not there for the music, and because it was Christmas Eve they were generous. By the time the musicians called it a night, they had made $10 in tips.

With Red's help, Parks found a room in a boardinghouse a few doors down from Pope's. There he slept in a bed for the first time since leaving his sister's house.

When Parks awoke on Christmas Day, he went to a nearby restaurant, where he got his first glimpse of his new employer. Pope, who arrived in a big cream-colored car, dressed like a preacher except for his pointy-toed yellow shoes. His face looked mean, and his eyes were filled with contempt for everyone in sight. Pope controlled all the rackets—gambling, prostitution, and other criminal ventures—on the northeast side of Minneapolis. It was clear he was armed, and without a doubt he was dangerous. Parks kept his distance.

His job at Pope's came to an abrupt halt a few days later, on New Year's Eve. Everyone seemed to be having a good time, but suddenly someone plunged a knife into a customer's neck. Parks fled through the back door just as the police arrived, and he ran past the bloodied corpse in the snow-covered alley. Pope's world was definitely not for him, Parks decided as he hopped a trolley bound for St. Paul.

Although he had only worked at Pope's for a week, Parks had made enough money to be able to afford to stay in another boardinghouse. When Mechanics Arts High School reopened that January, he returned to the classroom. He had trouble concentrating on his schoolwork, however. At his new landlady's insistence, he kept her company every night in lieu of paying rent.

Parks's failure to do his homework led the principal, Mr. Long, to threaten him with expulsion. The warning jolted Parks once again into taking a stand.

It was time to get serious about what mattered most: getting an education.

A few nights later, Parks came home late after searching for work. His landlady began to yell, demanding to know where he had been and what he had been doing.

"Since when do I have to tell you where I've been?" Parks retorted.

Screaming with rage, the woman attacked him. When he began to defend himself, several people joined the landlady in her attack. Parks grabbed a

Passengers board a Minneapolis–St. Paul trolley car in the late 1920s. The sign in the vehicle's window—Ride the Street Cars. The Safe, Sure Way—might have elicited a wry grin from Parks, who spent weeks on the cars, sleeping and doing his homework in their relative warmth and comfort. "In those days," he said later, "I never thought about success. I thought about survival."

chair and started swinging it wildly. Finally, realizing that he was outnumbered, he snatched up his belongings and ran.

His jaw throbbing from a well-aimed punch, Parks headed straight for the pool hall. He huddled by the radiator and tried to calm his jangled nerves by concentrating on his homework. When the pool hall closed, he boarded a trolley and continued to study through the night.

On his way to school early the next morning, Parks, his stomach empty and his jaw still sore, spied a flock of pigeons swooping down between two buildings. When one of them smashed into the nearest building and broke its neck, Parks picked up the bird. After plucking its feathers and cleaning it with his pocketknife, he built a fire from scraps of wood and paper, then roasted and ate the pigeon.

Parks arrived at school early, so he curled up in a warm corner of the boiler room and fell into a deep sleep. The custodian woke him in time for him to get to class. "You ought to tell Mr. Long about your problems," the man suggested, giving Parks some biscuits and coffee. "He might be able to help you." Parks promised as he rushed off to class that he would talk to Long. But he was too proud to tell anyone about his plight.

The only person Parks had turned to was his sister. Maggie Lee had not abandoned her brother even though her husband had thrown him out. She and Parks had worked out a plan that involved his slipping down the alley behind her house under the cover of darkness and picking up whatever food or money she was able to leave in a box on the back porch.

While pushing himself to keep up with his schoolwork, Parks scoured discarded newspapers for job openings. Tired of being told he was not qualified for this job or that because he did not have a high school diploma, he was determined to put an end to that excuse by graduating.

Despite his vow to make something of himself, Parks learned over the course of that first harsh winter in Minnesota that for a penniless black teenager without family support, succeeding in the world demanded a whole lot more than desire. That became especially clear to him after he abruptly left St. Paul one morning in March, thumbing rides in subfreezing temperatures to get to Bemidji, Minnesota, a small town where he planned to land a job playing piano in a place called the Stumble Inn. Once there, not only did the inn's owner turn Parks away because he was black, but a couple of drunks in a local diner where he stopped for coffee jeered at him as well. At that point, he resolved that he would never allow his skin color to become an excuse for lack of success.

In the same month as Parks's disastrous trip to Bemidji, Herbert Hoover was sworn in as the 31st president of the United States. Orphaned at the age of 8, Hoover was a self-made businessman who symbolized America's belief in individual enterprise. He maintained in his inaugural address, "We shall soon, with the help of God, be in sight of the day when poverty will be banished from this nation."

With the coming of spring in 1929, Parks began to share Hoover's optimism. He landed a job as a bellboy at the Minnesota Club, a gathering place for St. Paul's wealthy men. Inside its spacious rooms, bankers and railroad tycoons, judges and industrialists hobnobbed over platters of roast pheasant and duck, grilled steaks, and steaming plates heaped with wild rice and vegetables. There was plenty of everything, and Parks was able to eat his share discreetly behind the scenes.

Parks was also able to broaden his education. From the club's library, he borrowed newspapers, novels, and volumes of poetry. He listened carefully to the conversations of club members whose cigars he lit, whose coats he hung up, whose after-dinner brandy he served. Theirs was a world Parks studied,

absorbing as much of its cultural and social elements as he could.

Parks's attentiveness was rewarded one day, when a judge who belonged to the club was trying to recall the name of the author of the novel *Arrowsmith*. As was his custom, Parks was standing nearby, in case anyone needed his services. Overhearing the judge, he said, "Pardon sir—if you don't mind—it's Sinclair Lewis."

"Lewis. Sinclair Lewis, that's it," said the judge, as if the name had suddenly just popped into his head. Though the man never acknowledged the bellboy's presence, a couple of days later he handed Parks a small package. Ripping off the wrapping paper, Parks found a first edition copy of Edith Wharton's 1920 novel, *The Age of Innocence*. Thanking the judge profusely, he carried the book to school for days, showing it to everyone he knew.

Three of Parks's sisters, one of his brothers, and his father moved to St. Paul that spring. Although it had been months since they had seen one another, when Parks's father stepped off the train, he looked at the skinny young man standing there to meet him and said, "Well, boy, how have things been going?"

"Just fine, Poppa," Parks lied.

"You're skinny as a jackrabbit," his father said. "Been eatin' enough?"

Not wanting to admit how bad things had been, Parks assured his father that yes, indeed, he was eating well and life was just wonderful. His statement was not entirely false; things were definitely looking up. That spring, he had met Sally Alvis, and over the summer, while Parks managed to save most of the money he earned at his job, their courtship evolved to the point where they were ready to get married. Sally convinced him, however, that they needed to graduate from high school first. Accordingly, Parks was back at high school in September, more intent than ever on finishing his studies.

Soon after she met Parks in the spring of 1929, Sally Alvis gave him this photograph. Inscribing it "Lots of Love," she signed herself as "Sallie," a then stylish way of spelling her old-fashioned name.

The bubble burst on October 29, 1929, when stock prices plummeted on the New York Stock Exchange, sending the nation's economy into a downward spiral that rapidly led to banks and businesses closing their doors. Hundreds of thousands of people, including Parks, lost their jobs in what would be known as the Great Depression. By the following year, the number of unemployed in America would reach 4 million. Hoover's message of hope, applauded only a year earlier, became an object of derision.

When Parks lost his job in November 1929, he spent the next few weeks tramping through the streets in search of employment. In January, he decided to try his luck in Chicago. Hopping a freight train, he

Clowning for the camera, Parks and Alvis enjoy an afternoon at a St. Paul picnic ground. Although the 17-year-old Parks suggested marriage, his sweetheart insisted that they complete their high school education before taking the step.

spent a couple of frigid nights in a boxcar with a hobo and a trumpet player. By the time the train pulled into Chicago, the trumpet player was suffering from severe frostbite; when Parks left to get help, the hobo stole his blanket and bag.

With nothing more than the clothes on his back and a few dollars in his pocket, Parks set off to find a place to stay. He wound up in the Hotel Southland, a flophouse filled with tiny, unheated rooms. The manager, a cigar-chewing fat man named John, offered Parks a job cleaning the place for a dollar a day plus room and board. He accepted the position immediately.

The next morning, Parks discovered what a vile job he had accepted. The Hotel Southland was dirty beyond belief and filled with men so down on their luck that living in filth had become their way of life. The rooms and hallways smelled of stale bodies, excrement, alcohol, and smoke.

Still, Parks decided to stick it out for a few weeks. But when he tried to collect his wages one Saturday

night, John shoved him down and started to kick and punch him in a drunken rage. Parks struggled to his feet, then began to fight back, eventually knocking his employer unconscious. Taking only the money John owed him, Parks fled from the hotel. He headed for Union Station.

Inside the washroom at the train station, Parks ran into his mother's brother Pete, who was a railroad porter. "What happened to you?" his uncle asked, alarmed at the blood on his nephew's shirt.

"I've got to get out of here," said Parks. "I'm in serious trouble." He was horrified by the thought that he might have killed someone.

Uncle Pete smuggled Parks onto a private sleeping car of a passenger train bound for St. Paul. After he washed up and donned clean clothes, he crawled into bed. The rhythm of the train was as soothing as a lullaby, and he soon fell into a deep sleep. 🐾

4

"NO LOVE"

D URING THE EARLY months of 1930, the nation's spirit sagged under the weight of poverty and unemployment. Day after day, thousands of hungry people shuffled onto breadlines and waited outside soup kitchens for public relief. Newspaper photographs and magazine articles provided a steady account of the devastating effects of the Great Depression.

Parks moved into the St. Paul home of his sister Cora. Along with her 11-year-old son, Maurice, and her spunky teenage daughter, Marcella, who reminded Parks of his mother, they scraped through the remaining months of winter, stealing coal from loaded trucks and dismantling wooden fences to burn in the furnace. Surrounded by members of his family, Parks found it much easier to endure economic hardship this time around.

Parks's luck took a surprising turn for the better when he found a part-time job cleaning a drugstore. By the time summer approached, life seemed a little less grim, until a quarrel with Sally in July resulted in their breakup. Deeply upset, he turned to the piano for solace. He even began to carry a notebook with him, jotting down ideas for songs and snippets of tunes. From these notes emerged a song he called "No Love." Never having learned to read music, he invented a notation system based on numbers so he could write down his composition.

Parks discovered in music a means of expression that first took on the form of lovelorn lyrics and later the more traditional forms of the concerto, musical

An Oklahoma farmer, displaced by the dust storms that ravaged the Midwest in the 1930s, heads west with his worldly belongings. Parks, who took the farmer's picture, said, "I felt, without really knowing how, that photography was the one way I could express myself about deprivation, about racial discrimination."

scores for films, and the score for a ballet, and the one he valued above all others. Although he would pursue other vocations, he would return again and again to this discipline. Music would always be the art form that Parks found the most mysterious

In 1930, however, Parks did not turn only to music; he also immersed himself in books, reading the works of such writers as James Joyce and Thomas Mann. He tried his hand at writing short stories and poems as well as at sculpting and painting. At the same time, he was pushing himself hard on the basketball court, playing for both the Diplomats and his high school team. Season after season, he packed an astounding amount of activity into each day, allowing himself little time for sleep. Finally, in October 1931, he collapsed in the middle of a basketball game. His body had simply given out.

The family doctor diagnosed Parks's condition as physical exhaustion. In less than 3 months, he had lost more than 40 pounds and was so fatigued that he was on the verge of a complete physical breakdown. The doctor told him he must leave school for the rest of the year and stay home in bed.

Racing to hurdle all the barriers that society had placed in his way, Parks had set too fast a pace for himself. For the next five months, he closed himself off from the world and brooded. Only gradually did he regain an interest in his former activities.

The young man who emerged from isolation in the spring of 1932 was nearly 20 years old and a much wiser person. He realized that he had tried to achieve things much too quickly. Attaining the kind of life he wanted demanded not only desire and effort but time. No matter how determined he was, some of the things he wanted to accomplish were going to take a while.

Shortly thereafter, Parks was hanging out in his favorite pool hall when he overheard two men arguing

Wealthy Minnesotans attend a 1930 banquet at the Hotel St. Paul, site of Parks's debut as a busboy. Graduating to the position of head busboy at the Hotel Lowry, Parks got his first big chance when Larry Duncan's orchestra played his song "No Love" on a nationally broadcast radio show.

about whether or not a well-known local bandleader had a mustache. Parks was riveted by the boast one of the men made. A waiter at the Hotel St. Paul, he bragged that he ought to know because he rubbed shoulders with the bandleader every night. The man's comment gave Parks an idea.

Early the next morning, Parks went to the Hotel St. Paul to apply for a job as a waiter, a position he had never held before. He was given a chance to show what he could do, but his inexperience lost him a shot at waiting on tables. He was offered a job as a busboy instead. Because it still got him inside the hotel and close to visiting orchestras, he accepted the position.

Over the next few months, Parks met several well-known musicians. Although they gladly talked with the eager young man who showed them some of the

songs he had written, none offered Parks more than an encouraging word.

By August, Parks had become the head busboy at the Hotel Lowry, a job that gave him access to a piano. Every day, between the time when the lunch crowd left and the tables were set for dinner, Parks had three idle hours during which he could sit at the hotel's grand piano and compose. One afternoon, when he was playing "No Love," a man named Larry Duncan happened to wander by. He was the leader of the orchestra playing at the hotel that week.

"Is that your music?" Duncan asked.

Parks assured him that it was.

"Go ahead," Duncan said. "Play it again."

Duncan listened attentively a second time. Then he asked if Parks would like to have it orchestrated.

"I sure would," said a thrilled Parks.

Duncan sent his orchestral arranger to write out the music as Parks played "No Love" on the piano. Two days later, Parks gave Duncan permission to play the song during a live radio broadcast that the orchestra was to make the following evening. In his excitement, Parks phoned Sally, breaking a silence that had lasted for months. After telling her 'No Love" was going to be heard on national radio, he said, "I composed it for you—don't forget to listen."

On the evening of the broadcast, Parks was nervously filling up the diners' water glasses, impatient for the show to begin. Finally, the orchestra's vocalist walked up to the microphone. Just then, a man began to tap the side of his water glass with a spoon. "Water! Water!" he cried.

As Parks sighed and turned to pick up a pitcher, he noticed the headwaiter waving him off and filling the man's water glass himself. The waiter explained to the people at the table that Parks had composed the song the orchestra was playing. Soon, everyone in the room knew he had written "No Love"; all eyes

were upon him. When the song ended, the room
burst into applause.

"It was beautiful," Sally sighed when Parks called
her a few minutes later. "Would you like to come
over sometime, maybe tonight?" His lament over
having lost his girl became the means by which he
regained her.

A few weeks after the broadcast, Duncan asked
Parks if he would like to travel with the band after
it ended its run at the Hotel Lowry on Saturday night.

Parks was stunned. "Are you serious?" he asked.

"You've got two days to think it over," Duncan
told him.

Parks said he did not need two days. He was eager
to go.

And so it was settled: The black busboy would go
on the road with the white orchestra. The differences
in race did not bother Parks nearly as much as telling
Sally did. The night before his departure, he took
her out for a stroll. After trying to summon up the
right words all evening, he finally blurted out, "I'm
leaving with Larry's orchestra early tomorrow morn-
ing and I'm going to make enough money to come
back and marry you."

"Are you proposing?" Sally asked.

"I think so. If I am, do you accept?"

The look in her eyes was answer enough.

The orchestra's first engagement was in a hotel
in Kansas City. Between sets, Parks performed "No
Love" and played requests from the audience. This
arrangement satisfied him. But he was upset by Dun-
can's refusal to discuss a salary. Parks eventually had
to ask the band manager for a little cash.

By all appearances, Duncan had lost interest in
his orchestra; he traveled in a private car, dined sep-
arately, and rarely showed up for rehearsals. By the
time the troupe made it to Cleveland for an engage-
ment in late February, everyone in the band seemed

unhappy. The overall mood changed when Duncan showed the band a telegram he had received from his agent. It said they had an engagement to play at the Hotel Park Central in New York City on March 3. Because most of the band members had family in New York, they were cheered by the news. For Parks, going to New York meant heading farther away from Sally and his family.

Parks managed to convince himself that he would make his name as a composer in New York. Well known for its bright cabaret lights and glittering marquees, the city boasted some of the nation's top night spots, such as the Savoy and the Cotton Club. A number of black entertainers, including the bandleaders Duke Ellington and Cab Calloway, had made their name in New York.

As the band's bus rolled into the city by way of the Lower East Side, Parks's visions of grandeur faded at the sight of the run-down tenements and overcrowded streets. It was his first indication that New York was not the paradise he had thought it would be.

When the bus pulled up in front of the Hotel Park Central, the doorman pulled Parks aside and told him he would have to enter the building through the servants' entrance. "I'm not a servant," Parks said. "I'm a member of the band."

"Makes no difference," the doorman responded. "You're colored. You can't go in the front way."

As it turned out, that was the least of Parks's worries. An hour after their arrival, the musicians received word that Duncan had decided to disband the orchestra. Parks, with only a few dollars in his pocket and no place to go, was stranded in a strange city.

Over a cup of coffee, one of the musicians told Parks to go to Harlem, the city's black uptown district. Early in the 20th century, Harlem had become

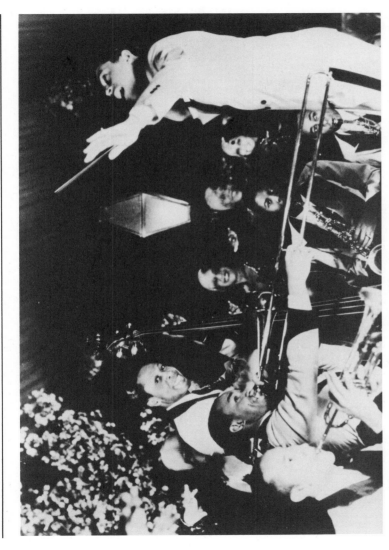

Cab Calloway leads his orchestra at Harlem's Cotton Club in 1930. Eager to hear such celebrated black groups on his 1932 visit to New York City, Parks soon discovered that most of them played in segregated night spots. The Cotton Club, for example, featured only black performers but admitted only white customers.

a symbol of hope and freedom to blacks throughout the nation. By the 1920s, it was home to the largest black community in the United States. The black artists and intellectuals who settled there soon created a revolution in black culture that came to be known as the Harlem Renaissance.

By the time Parks arrived in Harlem, however, its residents were beginning to feel the effects of the Great Depression. The stock market crash, which had initially seemed to affect only the whites who worked downtown, in the city's financial district, soon touched Harlem. In the coming years, the depression would hit the black community harder than any other part of New York City. Nearly half of the district's 200,000 residents would lose their jobs as Harlem suffered a total economic collapse.

Parks took a room on St. Nicholas Avenue in Harlem and spent his days walking the streets of the

city in search of work, only to hear time and time again that there were no jobs available. Deeply discouraged, he eventually struck a deal with a dope dealer named Charlie who lived down the hall. For a dollar per package, Parks delivered marijuana to Charlie's customers and collected payment from them.

One night, two policemen burst into Parks's room and began to beat him. When they discovered that they had mistaken Parks's room for Charlie's, they broke down Charlie's door. All they found were some empty boxes and crumpled-up newspapers. Someone had tipped Charlie off, and he was gone.

Parks was fortunate because his role in Charlie's dealings never came to light. Yet his brush with the law and his failure to find a job pushed him to the brink of admitting he would never make it in New York as a composer. When he was evicted from the rooming house for not paying his rent, he considered hopping a freight train and heading home. Then he came into a bit of luck.

One afternoon, Parks was wandering along Broadway when he spotted a sign in a third-floor window. It read: W. C. Handy Publishing Company. Parks had stumbled on the building that contained the offices of perhaps the leading blues composer in the country. Screwing up his courage, Parks climbed the stairs and knocked on the office door. "Come in!" shouted someone inside. Parks entered and found a chubby, middle-aged black man sitting at a rolltop desk.

"Are you Mr. Handy, the famous composer?" Parks asked. No, the man at the desk replied, he was Handy's brother Charles. When Parks said that he, too, was a composer, Charles Handy directed him to a piano in the corner and asked him to play.

Parks fumbled his way through a few tunes before Handy stopped him and said, "Tell me a little about

yourself." He listened sympathetically to Parks's tale about being stranded in New York after Duncan disbanded his orchestra, then told the young man that the odds against making a living as a composer were steep. Discouraged, Parks thanked Handy for his time and got up to leave.

"Hold on," Handy said. "You can ride uptown with me if you like."

Their destination turned out to be W. C. Handy's house. Parks was invited to stay not only for dinner but for the next few days, until Handy's daughter found him a room with some family friends. A short time later, Parks landed a job at a hot dog stand, a place where he often ate.

Only two weeks after Parks had gotten the job, the owner of the hot dog stand died. Parks and another person who worked at the stand, Bill Hunter, decided it was time to get out of Harlem. Together, they decided to enlist in the Civilian Conservation Corps (CCC), a government-sponsored program for men 18 to 25 years old who were willing to work on conservation projects in national parks and wilderness areas around the country. In return for planting trees, building ponds, feeding wildlife, and fighting forest fires, they were given room and board as well as a few dollars a month.

On April 19, 1933, Parks and Hunter boarded a bus bound for Fort Dix, New Jersey. This time around, New York had hardly lived up to its billing as the promised land. But the day would come when Parks would settle there, and his circumstances would be remarkably different.

In October, Parks left the CCC camp in Chenango Falls, New York, where he had been stationed since June, and began to hitchhike west, toward Minneapolis. Four days later, after he had reached Minneapolis, he married Sally Alvis. His brother Jack, who had recently been ordained a minister, witnessed

the young couple's vows in the parlor of Sally's parents' house.

Throughout the afternoon, Sally's father had stayed in the kitchen. He was angry because Parks had never formally asked him for Sally's hand, so he refused to take part in the wedding ceremony. He broke his silence only when the newlyweds were leaving to catch an eastbound train. He shook Parks's hand and said, "You got her. Now be sure you take good care of her."

Parks had arranged for Sally to stay in a rooming house in Binghamton, New York, near the CCC campsite in Chenango Falls. When his CCC company was moved to a new camp near Philadelphia in March 1934, Sally resided in a family's house in the area. That spring, the Parkses discovered that they would soon be starting a family of their own.

Because millions of Americans needed work, President Franklin Roosevelt had set a limit on the length of time that each person could serve in the CCC. With his days in the corps drawing to a close and a baby on the way, Parks and his wife decided in July 1934 to return to Minneapolis and accept an invitation extended by Sally's parents: The young couple moved into a room in the Alvises' house.

With the help of Sally's brother, Parks got a job as a busboy at the Curtis Hotel. Before long, he was promoted to waiter, a position that once again exposed him every night to the sounds of a hotel orchestra. Parks also resumed his habit of composing songs during lulls in his afternoon duties. By the time Sally gave birth to Gordon, Jr., in December 1934, several of Parks's songs had been orchestrated and played live on a local radio program.

The following summer, Parks landed a job as a piano player in an after-hours club called Carver's Inn. He enlisted Red, the drummer from Pope's, as his accompanist. Over the next year and a half, Parks

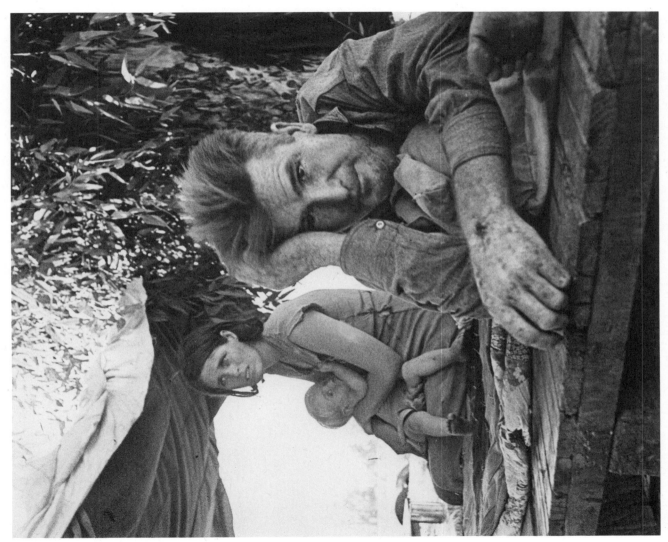

"Desperation," photographer Dorothea Lange's stark image of a homeless family during the Great Depression, started Parks thinking about the power of documentary photography, an art at which he would soon excel.

made enough money working at the hotel during the week and at Carver's Inn on weekends to move his family out of the Alvis household and into an apartment two blocks away.

Yet Parks remained restless. One afternoon, he told Sally that he was tired of his jobs and of Minneapolis. He wanted to try to do something else for a living.

"I've known that for a long time," she replied. "What have you got in mind?"

Working as a waiter on passenger trains was his reponse. By June 1936, he had landed a job on the Northern Pacific's continental run through Minneapolis, Chicago, and Seattle.

During his first layover in Chicago, Parks walked along the same streets he had first traveled during a bleak winter six years earlier. He stopped at the Hotel Southland, where to his relief, he spotted fat John in the lobby, looking none the worse for the beating Parks had given him years ago. Finally, Parks was free of the nagging fear that he might have killed a man.

Despite the demands of his waiter's job, Parks usually found the time to pick up a book after the dining car closed in the evening. Although he had never returned to high school to earn his diploma after his five months of convalescence, he had not stopped reading. One night, he picked up a magazine another waiter had cast aside and was mesmerized by its photographs of migrant workers—hungry-eyed families prowling America's highways in search of work. Suffering from both the Great Depression and the Dust Bowl storms that had turned once-fertile farmlands and prairies into fallow fields of dust, these people roamed the midwestern countryside or congregated in communities of shacks on the outskirts of cities. Parks studied their images, responding for

A Georgia farmer plays an accordion solo in this haunting study by FSA photographer Jack Delano. Parks was hypnotized by the work of Delano, Dorothea Lange, and Walker Evans, photographers who traveled across the nation to portray those Americans hardest hit by the national economic collapse.

the first time to the impact of documentary photography.

Taking the magazine home with him, Parks thumbed through the photos again and again. He committed the photographers' names to memory: Dorothea Lange, Walker Evans, Jack Delano. They worked for the photography division of the federal government's Farm Security Administration. Like the people they captured on film, the photographers also roamed the country, not in search of work but on the lookout for subjects with which to document life in depression-ravaged America.

Parks immersed himself in this episode of American history by reading the books of such contemporary American writers as John Steinbeck and Erskine Caldwell. Soon, a restless need for change stirred in him once again.

One December morning in 1937, as he strolled the streets of Chicago, Parks found himself standing in front of the Chicago Art Institute. He went inside, intending to stay only long enough to warm up, but was awestruck by the paintings he saw on exhibit. Later that same day, he went to a movie, only to be intrigued more by the newsreel shown before the movie than by the film itself. The newsreel featured on-the-spot footage of Japanese warplanes sinking an American gunboat in China's Yangtze River. Parks was impressed by the skill and courage of the photographer who had kept his camera rolling throughout the entire incident so that viewers could witness the grim event. Parks saw a parallel between the way this photographer depicted war and the way the FSA photographers had documented poverty.

Parks was thrilled when the lights came up and Norman Alley, the photographer who had shot the newsreel footage, stepped onto the stage to talk about his experience. After Alley spoke, Parks sat through

a second showing of the newsreel. By the time he left the theater, he had decided to become a photographer, even though he did not own a camera and had never really used one.

When the train on which he was working pulled into Seattle a few days later, Parks set out to purchase a camera. He soon discovered that the $17 in his pocket was not going to buy a brand-new piece of equipment. Finally, in a pawn shop, he found a Voigtlander Brilliant for $12.50.

After spending half an hour struggling to load the film into his new camera, Parks began walking around the city, shooting pictures of anything that caught his eye—buildings, signs, people. While trying to get some shots of sea gulls from a wharf on Puget Sound, he tumbled into the water. He managed to hang onto the camera, and somehow the film remained unspoiled.

When Parks had the roll of film developed at the Eastman Kodak store in Minneapolis, the man behind the counter told him he had a good eye. "Keep it up and we'll give you a show," he added. Six weeks later, a group of Parks's photographs was displayed in the store's window. ❧

5

BEAUTY AND THE BEAST

❦

DURING THE EARLY months of 1938, Gordon Parks spent his free time on the train where he was employed by studying the works of other photographers and reading handbooks on various camera techniques. He began to take pictures whenever he got the chance—portraits of Sally, scenes of clouds and sand dunes, images of skiers. Eventually, the *St. Paul Pioneer Press* featured some of his work.

Whereas Parks's passion was photography, his livelihood remained waiting tables on the North Coast Limited. But that came to an end when he tangled with a southerner named Barnes, who took over as headwaiter in early 1938. Contemptuous of "young uppity nigras" who read books, Barnes loaded down the 25-year-old Parks with extra work so that he would not get a chance to read. The harder Barnes tried, however, the more Parks would resist him. No matter how tired he was, he read almost every night.

One day, Barnes purposely bumped into Parks when he was carrying bowls of hot soup. The soup not only splashed Parks's arms but spattered some customers. Furious, Parks shoved Barnes into the pantry and held a knife against his throat. Two other waiters pulled them apart, and Barnes backed away without saying a word. A few days later, Parks was fired. He was offered the chance to get his job back if he apologized to Barnes, but he refused.

During this same time, Sally took Gordon, Jr., and moved back to her family home. The marriage had been shaky for several months. She divorced Parks a short time later.

Unemployed and unmarried, Parks went to live with his sister Cora in St. Paul. After several fruitless months of job hunting, he received an unexpected offer: He was invited to play basketball on a semi-professional team that was a forerunner of the Harlem Globetrotters. The players entertained the crowds by "befuddling," or playing tricks on, their opponents. After a month of training, he joined the squad on a three-month-long barnstorming tour through Minnesota, North Dakota, and Iowa.

Shortly after the tour ended, Parks ran into Sally at a party. Although each had arrived with a date, by the end of the evening they had planned a weekend outing together. A week later, admitting that their divorce had been a mistake, they remarried.

Parks soon got another railroad job, this time as a porter on Chicago-Northwestern Railroad's, "400," a passenger train that traveled from Minneapolis to Chicago. One day, he noticed a passenger carrying a camera bag with *Life* stamped on it. Parks soon found himself in a conversation with Bernard Hoffman, one of *Life* magazine's staff photographers. "Come and work with us someday," said Hoffman when he got off the train in Chicago. Parks laughed and promised he would.

An admirer of the sort of fashion photography he saw in publications such as *Vogue*, Parks set out to sell his services to department stores in Minneapolis and St. Paul. Although he was turned down regularly, he persisted, until one evening at Frank Murphy's, a fashionable women's clothing store in St. Paul, he got a break.

Seeing her husband ushering Parks out of his office, Murphy's wife asked, "What does he want, Frank?" When she heard that Parks wanted to shoot

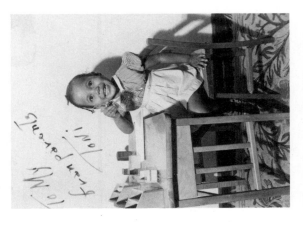

Toni Parks autographed this snapshot of herself for her grandparents. The second of Gordon and Sally Parks's three children, Toni was born in 1940.

fashion photographs for the store, she offered to give him a try. The following evening, Parks spent several hours taking pictures of an array of stylish models. Mrs. Murphy, who oversaw the shoot, complimented Parks on his skillful use of lights and camera. She did not know that he had borrowed most of the equipment and had taken a crash course in how to use it only hours earlier.

Parks's brash confidence in his ability to pass himself off as a professional photographer crumbled in his darkroom at two o'clock that morning, when he discovered that he had double-exposed all the photos he had shot except one. "My life is ruined! Your life is ruined! The whole damned world is ruined!" he shouted to Sally after waking her up to tell her what had happened.

"I'd blow up the good one," Sally said before going back to sleep.

Following her advice, Parks enlarged the photograph and encased it in an elegant frame. When Mrs. Murphy saw it that afternoon, she promptly forgave Parks after he told her what had happened to the other pictures he had taken. "Forget it," she said. "We've got more work to do."

Parks quickly became Mrs. Murphy's favorite photographer. Over the next few weeks, his work was displayed throughout Frank Murphy's, including the store's front windows. The photographs caught the eye of many passersby, including Marva Louis, wife of heavyweight champion Joe Louis.

"I saw your wonderful photographs at Frank Murphy's," Marva Louis said when she phoned Parks, "and I think you are wasting your time here. Why don't you come to work in Chicago? I could get you a lot of work there."

It took Parks a while to take advantage of her offer. Following the birth of his daughter Toni in 1940, he was unwilling to give up his job with the Chicago-Northwestern Railroad and try his luck as a

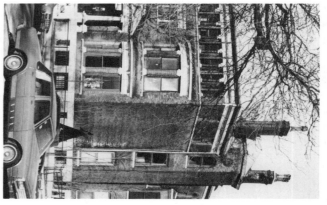

Parks held his first photographic exhibition at Chicago's Southside Art Center (above) in 1941. Offered darkroom space in the center by its assistant director, Parks had quit his job on the Chicago-Northwestern Railroad and moved to Chicago in 1940.

full-time free-lance photographer. With a growing family, he needed a source of steady income.

That sentiment changed, however, one afternoon during a layover in Chicago, when Parks visited the Southside Art Center. There he ran into David Ross, the center's assistant director. As the two men talked, they discovered that their wives were friends, and after several hours of conversation the two men had established a warm friendship of their own. When Parks told him about Marva Louis's offer, Ross said, "Well, what's keeping you?"

"A studio or someplace to work from," Parks replied.

"We've got a fully equipped darkroom at the center, with nobody in it," Ross said. "We need a photographer and you need a place to work. We couldn't pay you anything but you wouldn't have to pay rent."

Two days later, Parks resigned from his job at the railroad. He and Sally packed up their belongings, put them in a beat-up old Ford, and headed south, to an inexpensive apartment Ross had found for them in Chicago. Although the rooms were dingier than they had hoped, a little elbow grease and some fresh paint brightened not only the decor but their spirits.

When Parks phoned Marva Louis to tell her that he was ready to take up her offer, she proved to be true to her word. With her help, as well as that of the art center's board of directors, Parks soon had all the photographic assignments he could handle. After a local newspaper featured a series of photos he had shot of Marva Louis, offers of work came flooding in.

Parks thought that fashion photography was fun, and it paid well. Yet he never lost sight of his interest in using his camera to document the poverty he saw all around him. Occasionally, he would roam Chicago's South Side ghetto, photographing its drab tenements, trash-infested lots, and the weary faces of its residents.

On one such excursion, Parks stumbled upon a black family standing in a vacant lot. The father held a shovel. The heads of his wife and two children were bowed in funereal sorrow. Puzzled by the scene, Parks nevertheless raised his camera and photographed it.

As the family walked toward a nearby tenement house, Parks followed them. Along the way, he passed a mound of freshly turned dirt with a board sticking out of it. On the board, beneath a crude crayon drawing of a dog, were scrawled the words *Bucky, our friend*. As Parks paused to photograph the board, the man with the shovel turned to ask suspiciously, "What you doin' there, fella?"

"Would the kids like a picture of the grave?" Parks asked. One of the children, a little girl with tears on her cheeks, nodded. When Parks convinced the father that his offer of a photo would not cost them anything, the man invited the photographer into their home, a tiny apartment lit by a single bulb, with little plaster left on the walls and a filthy bathroom down the hallway. After hearing that Parks planned to document the effects of poverty on Chicago blacks, the man welcomed him to photograph the place his family called home.

"See that baseball bat in the corner?" he said. "Well, my boy there don't play ball with it. We use it to kill rats. There's three times more rats in here than there is Negroes. Got so my wife and me have to sleep in shifts to keep 'em from gnawin' up the kids." The man had got Bucky to fight the rats, but the dog had died from eating rat poison.

Parks quickly learned how harsh life was on the South Side. Assaults and killings occurred frequently, forcing him to use caution as he walked the streets and alleys, attempting to document the effects of poverty. However, as tough as life was on the South Side, the churches scattered throughout the neighborhood gave signs of hope. On Sundays, Parks pho-

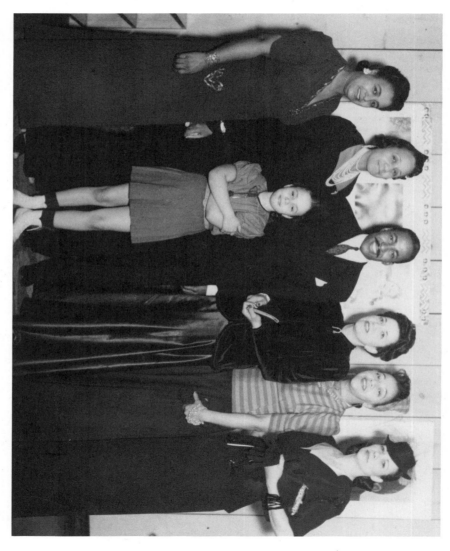

Flanked by patrons of Chicago's Southside Art Center, Parks flashes a triumphant smile at the opening of his 1941 photographic exhibition. To the surprise of some of the exhibit's elegant guests, Parks invited not only the society people he had photographed but the poor Chicago blacks whose lives he had chronicled with his camera.

tographed churchgoers in their finery, including an elderly missionary woman who posed for him wearing a white bonnet and clutching her bible. "Religion is all we got left," she said.

The next afternoon, Parks showed his photographs of the old woman to a white society matron whose portrait he was shooting. She remarked, "A darling old lady, an awful lot like the mammy we had as children." Parks ignored her comment and continued with the photo session. He used the exorbitant fees that he charged wealthy women to buy the film he needed to document life among Chicago's poor.

Over the next year and a half, Parks created a portfolio filled with samples of his best fashion and

documentary photos, landscapes, cityscapes, and portraits. By 1941, he had decided to apply for a grant from the Julius Rosenwald Fund, which offered its recipients $200 a month to study their art for a year wherever they chose. Long before he had ever dreamed of the possibility of winning a fellowship, Parks had decided that he would like to study photography in Washington, D.C. There, he could learn from the Farm Security Administration photographers whose work had first inspired him to pick up a camera.

In the fall of 1941, the Southside Art Center exhibited a number of Parks's photographs. In addition to inviting artists and art patrons to the opening night party, Parks included the people—rich and poor, black and white—who were the subjects of many of his photos. Both the elderly missionary woman and the society matron showed up, standing next to their portraits, which Parks had hung side by side, and giving interviews to the press.

FSA photographer Jack Delano came, as did two representatives from the Julius Rosenwald Fund. By the end of the evening, Parks glowed from the warm reception given his work. Yet he was still weeks away from learning whether or not he would receive a fellowship.

When Parks finally received an envelope from the Rosenwald Fund in late November, he expected the worst. "Here," he said, handing it to Sally, "give me the bad news." After reading the enclosed letter, Sally lit up. "You made it," she said. Parks, at the age of 29, thus was awarded the first Rosenwald fellowship ever granted to a photographer. A short time later, he received a letter from Roy Stryker, head of the FSA's photography division, telling him he was expected in Washington, D.C., on January 1. ◆

To Evelyn —
With great regards
and best wishes
[signature]

6

A CHOICE OF WEAPONS

❦

GORDON PARKS SET out to learn as much as he could about documentary photography in 1942, during his stay in Washington, D.C. But he did not have an easy time of it. One day, fellow Farm Security Administration photographer John Vachon invited him to lunch in the FSA cafeteria. Until that day, Parks had avoided the cafeteria because he had noticed that the agency's few black employees always ate in the back of the room. When he and Vachon sat down in the front section, the cafeteria manager came over to their table and said to Parks, "You can't sit here!"

When Parks replied that he would eat there whether the manager liked it or not, the man complained to Roy Stryker. The usually good-natured FSA photography division chief told the manager in no uncertain terms that his employees ate wherever they liked. That would have been the end of the incident, if it had not been for the other blacks who watched Parks eat in the "white section" of the cafeteria over the next few weeks. "Young man," said a gray-haired black gentleman who confronted Parks in the hallway, "you're going to cause trouble for all of us."

Parks also came up against the unwritten rule that blacks should not fraternize with whites. That became abundantly clear when a white photographer named Marjorie Collins joined Parks and Vachon on their visits to black restaurants and jazz clubs. Not only

Ready for action, Parks awaits military orders in 1943. As a photographer-correspondent for the Office of War Information, he expected to follow the 332nd Pursuit Squadron into combat; but at the last minute—and with no explanation—the Pentagon canceled his clearance for overseas duty.

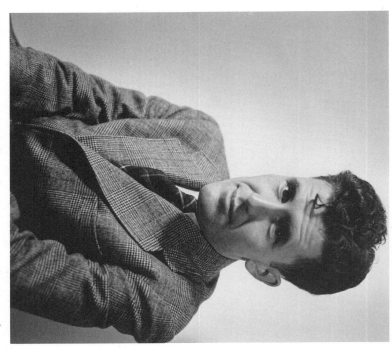

Parks and FSA photographer John Vachon often encountered hostility from bigots who resented their friendship. One evening a policeman, obviously enraged by the sight of a black and a white dining together, accosted them in a restaurant. "Are you white or colored?" he demanded of Vachon. The white photographer eyed him coolly. "I don't really know," he said. "My parents never bothered to explain it to me."

did the trio turn heads and set tongues wagging, but news of their association gave ammunition to several southern congressmen who wanted to abolish the FSA.

After a couple of months, Parks's family joined him in Washington. The discriminatory policies of stores and restaurants, as well as the racial hostility that blacks suffered in the parks and on the playgrounds, kept him from taking his children on the sorts of daily outings they had taken for granted back in Minneapolis. When Parks tried to explain to seven-year-old Gordon, Jr., why they had to stop going downtown for lunch and a movie together on Saturday afternoons, his boy looked up at him and asked, "Does the president know about this, Dad?"

At the same time, relations between Parks and Stryker grew tense. Tired of assignments that relied

only on an understanding of basic photographic techniques, Parks wanted to do more interesting work; Stryker insisted he needed to refine his skills before moving on to more complex projects. In addition, he criticized what Parks regarded as some of his best work. Finally, convinced that Stryker favored other FSA photographers and arranged exhibitions of their work throughout the country, Parks demanded that Stryker give him a solo exhibition, too.

"Gordon," Stryker said, "you can goddamned well think what you want. No individual photographers have been given shows, and I'm not going to make an exception for you. Furthermore, you're not ready for a show yet—not by a long shot."

Nevertheless, Parks was certain that his talent was going unappreciated. He concluded angrily that Stryker was a bigot, that all of his speeches about combating racism were nothing but idle talk. And when Stryker called Parks into his office toward the end of 1942, the photographer was certain that he would be fired.

The FSA was to be shut down, Stryker said, but its photography division was going to become part of a new government department—the Office of War Information (OWI). Although he had managed to save the division, he was allowed to place only a few FSA photographers on his new staff. Frankly, Stryker said, he wanted Parks to join him in the OWI, but there were several people in high places who were upset about his friendship with Marjorie Collins.

Parks was indignant. "You've spent all this time teaching me not to knuckle under to prejudice. I'm not about to do it now, even if it means I won't be going to the OWI with you."

Leaning back in his chair, Stryker smiled. "You're hired," he said.

Parks realized immediately how wrong he had been. Stryker had been under tremendous strain for

several weeks, first trying to save the FSA, then, when it had become clear that the agency was doomed, seeking to protect the photography division. Stryker had, in fact, showed his recognition of Parks's abilities in the most telling way possible: He had refused to get rid of Parks. Rather than cave in to public pressure, Stryker had given Parks one of the few available OWI staff photographer positions.

During the next 2 years, Parks handled a variety of assignments for the OWI, including photographing 13 black Americans who had achieved success in their chosen fields. Among the people he photographed were such notable individuals as Walter White, executive secretary of the National Association for the Advancement of Colored People (NAACP); singer and actor Paul Robeson; author Richard Wright; and Mary McLeod Bethune, educator and founder of Bethune College. Accompanied by a text written by Edwin R. Embree, director of the Julius Rosenwald Fund, Parks's photographs were published in the book *Thirteen Against the Odds*.

In early 1943, Parks requested an overseas assignment, and Stryker helped him get the proper correspondent's credentials, enabling him to join the Air Force's 332nd Pursuit Squadron, an all-black fighter group. The pilots were being trained to fight in World War II at Selfridge Field in Michigan prior to being stationed in England, where they were to accompany bomber runs into Nazi Germany. Parks was to document the group's training efforts and then fly on combat missions to capture its exploits in battle.

On the day he received the go-ahead, Parks rushed home to tell Sally, only to discover that she had just found out she was carrying their third child. "It's all right," she said, smiling. "We'll be okay. I'll go stay with Mom until you get back." A few days later, she left for Minneapolis, taking Gordon, Jr., and Toni with her.

Parks took this portrait of Richard Wright, author of such classic novels as Black Boy and Native Son, in the early 1940s. Parks and Wright liked each other as soon as they met: "We laughed and talked as if we had been friends for years," Parks wrote later. "When I left him, I knew I had shared time with a man of courage and deep conviction."

For the next several months, Parks spent his days at Selfridge Field with young black pilots who were preparing to fly combat missions. He not only flew with them but ate, bunked, and played cards with them. By December 1943, when the 332nd Pursuit Squadron received its orders to prepare for overseas duty, Parks had been accepted as one of the group.

The day before the squadron was to ship out, Parks was told his traveling papers were not in order and

Three generations of Yellowknife Indians sit for a 1944 Parks portrait. After Parks obtained medical and educational aid for their children, the appreciative Indians gave him his own spot on the Northwest Territories map: Great Gordon Lake.

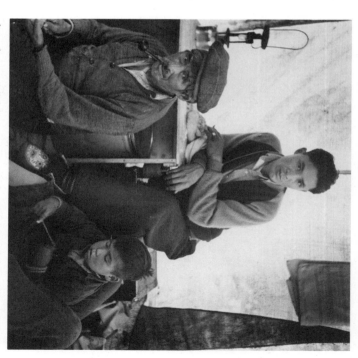

that he would have to go to Washington to get them straightened out. In the nation's capital, he was unable to find anybody to help him. Stryker had left the OWI to work for a company in New York, and everyone else he knew was gone for the weekend. Parks eventually located the head of the OWI, who told him to go to the Pentagon.

Several days of uncertainty followed before Parks got the confirmation he needed. Finally, his papers were in order, and he was cleared to rejoin the 332nd. He found the group settled in their barracks at Camp Patrick Henry, in Michigan.

Shortly after Parks arrived at the camp, a pilot told him that white paratroopers had beaten up a black groundsman. This attack was followed by an attempt to segregate all black military personnel at the base's movie theater. Although in some respects President Franklin Roosevelt took a liberal stance on black civil rights—he appointed more blacks to

prominent government positions than did any of his predecessors—racial segregation was still widely practiced in government agencies and in the military (with the exception of the merchant marine). Blacks were angered at being asked to give their life for a country in which "separate but equal" remained an unwritten law.

The next day, Parks saw his own plans shot down. Colonel Benjamin O. Davis, Jr., the leader of the 332nd, called him into his office and told Parks, "A final call from the Pentagon has come through. You will not be able to embark with us."

Stripped of his OWI credentials, Parks lost not only his chance to cover the war efforts of the 332nd but his job. At the age of 31, he was again out of work, with a growing family to support.

Once more, Parks decided to try his luck in New York. When he first lived there, he had hoped to earn recognition as a composer. This time, he intended to make his living with a camera.

Parks rented a room in Harlem, at the 125th Street branch of the Young Men's Christian Association (YMCA), and began to look for work. He knew that Stryker was setting up a photography division in a large corporation, Standard Oil, as part of the company's public relations campaign of offering free high-quality photographs of America to assorted magazines. His chances of being employed there as a photographer were slim, he felt, because it appeared that Standard Oil never hired blacks as anything but messengers and janitors. So he set out instead to find a job as a staff photographer with a fashion magazine. His first stop was *Harper's Bazaar*, where Stryker had said to contact an editor named Sarah Little.

Little and Alexy Brodovitch, the magazine's art director, raved about the quality of the photographs Parks showed them. But there was one important hitch: *Harper's Bazaar* was owned and published by

William Randolph Hearst, whose corporation made it a policy not to hire blacks. "I'm embarrassed and terribly sorry," Brodovitch said, "but that's the way it is. I hope you understand."

The next day, Parks met with the renowned photographer Edward Steichen, another referral of Stryker's. Outraged at the *Harper's Bazaar* incident, Steichen sent Parks to see Alexander Liberman, the editorial director of *Vogue*. Liberman, in turn, referred Parks to Tina Fredericks, senior editor at *Glamour*, who was impressed by his portfolio and offered him a lot of free-lance work. Still, the staff position Parks hoped for continued to elude him.

At the end of his first week in New York, Stryker phoned to ask Parks if he would like to work at Standard Oil. Whereas it was true that Standard Oil usually did not hire blacks, Stryker had insisted that if the company wanted him to head its photography department, he had to have free rein to hire whomever he pleased. Stryker hired not only Parks but photographers from a variety of ethnic backgrounds.

Following the phone call with Stryker, Parks felt it safe to move his family to New York. They settled in a house in the suburbs, and on March 4, 1944, Sally gave birth to the Parkses' third child, David.

In addition to his job at Standard Oil, Parks continued to work as a free-lance photographer. His first *Vogue* and *Glamour* fashion photos, appearing in the summer issues, caused his fellow photographers to chide him for wasting his talent on shooting fashion. But Stryker rose to his defense. "There's nothing wrong with your photographing fashion," he said. "It pays the rent."

Knowing Parks's skill as a portrait photographer, Stryker assigned him to shoot Standard Oil executives for the company's annual report. One executive balked at having his picture "taken by a nigger." But later, when all the portraits went on display, the same

executive called Stryker to complain about the quality of his portrait, which was not nearly as good as the rest. Who took all the other ones? he wanted to know.

"Oh," said Stryker coolly, "the nigger took them."

Not only did the executive ask Parks to reshoot his portrait, he hired him to take portraits of his entire family. "That was the way Roy trained you," Parks told a reporter several years later. "Keep your cool and prove through your work what you could do."

During the three years that Parks worked for Standard Oil, he spent a good deal of time traveling through upper New England and Canada, photographing life in rural areas and small towns. His last assignment was to photograph the prospectors, miners, and Indians who inhabited Yellowknife, a small town in Canada's Northwest Territories.

One day in Yellowknife, Parks accompanied an Indian named Chocko to his tribal camp. Upon seeing a tent full of sick children and listening to the chief's anxious questions about how to find help for his impoverished, disease-ridden people, Parks knew he had to do more than document their distress. He asked Stryker to send him $3,000, some of which he used to fly the children to a medical clinic in Ottawa. The rest of the money he reserved to pay for the education of a promising young Indian who, Parks hoped, would return one day to help his tribe. To show his gratitude, the chief sent Parks 10 feathers from his headdress and named a lake after him, in the vast wilderness that surrounded Yellowknife: Great Gordon Lake.

Parks capped off his years at Standard Oil by publishing his first book, *Flash Photography*, in 1947. The following year, he published another work, *Camera Portraits: The Techniques and Principles of Documentary Portraiture.*

Enjoying a relaxed evening at home are David Parks, perched on his father's shoulders; Toni and her mother, Sally, sharing the sofa at right; and Gordon, Jr., reading at left.

One of the traits Stryker valued most in photographers was the willingness to experiment. He believed that the best work was done by those who strove to avoid the monotony of a safe routine. Similarly, Parks feared that he would fall into a rut if he stayed on too long at Standard Oil. Besides, for years he had held onto one dream, that of holding a staff position at *Life*, the highest quality pictorial magazine in the country.

One day in 1949, Parks decided he had waited long enough. Portfolio in hand, he walked into the office of Wilson Hicks, *Life*'s picture editor. Hicks leafed through Parks's photos without saying a word.

When he finished, he called two other editors, John Dille and Sally Kirkland, and asked them to take a look.

Dille was looking for someone to shoot documentary stories. Kirkland, the fashion editor, was anxious to find a photographer to accompany her to Paris for an upcoming fashion show. Both liked Parks's work.

Peering over the top of glasses balanced on the tip of his nose, Hicks asked Parks what kind of assignment he would like. Without a clue as to how he would manage it, Parks said he would like to shoot a story on a Harlem gang leader. Dille said it sounded like a good idea to him. And just like that, Parks was given his first assignment for *Life* magazine. ◆

7

A PHOTOGRAPHER
FOR LIFE

❧

Having talked his way into an assignment for *Life* magazine, Gordon Parks did not know where to begin. He did not know any Harlem gang leaders. He was acquainted with a police detective, though, whom he promptly visited at a Harlem police station. When Parks described the assignment to his friend, the man laughed out loud. What gang leader would open up his life to coverage in a national magazine?

While Parks was talking with the detective, a light-skinned young black man walked into the room. The red tint of his hair suited his fiery disposition; he began to yell at the desk sergeant, who patiently listened to him for some time before saying something in return. "You wanted to meet a gang leader," Parks's friend said. "Well, that's the toughest one in Harlem." He explained that the youth's name was Red Jackson, and he was angry because he had cooperated with a police effort to calm gang violence by keeping his own gang, the Nomads, in line, but someone in a rival gang had shot one of the Nomads and thrown his body in the river.

Peering through a tenement window in 1948, Harlem gang leader Red Jackson keeps watch on his rivals. "Red didn't think of himself as a criminal," Parks said later. "He thought of himself as somebody who was protecting his turf, protecting his guys. They would have been sat upon if they had not banded together."
Parks's portrait of Jackson was part of a Life assignment that began a 20-year relationship between the great photographer and the great picture magazine.

Parks followed Jackson out of the police station and casually offered him a ride home. "You a cop?" Jackson asked.

"Nope," Parks replied, "a photographer for *Life* magazine."

After showing Jackson a copy of the periodical, Parks explained that he hoped to document the life of a gang leader over the course of several weeks. Hopping out of Parks's car on 116th Street, Jackson told him that he would talk the idea over with the other Nomads. When Parks showed up the next day, Jackson kept him waiting but eventually sidled up to the car and, with six other members of his gang, rode around Harlem with Parks at the wheel until 4:00 A.M.

Parks spent time with the gang for more than a week without anyone ever mentioning the story. Finally, Jackson turned to Parks and asked him when he was going to start shooting. From that point on, Parks was allowed to accompany the gang wherever they went; he attended their meetings, prowled the streets with them, and even went along when the Nomads barged into another gang's clubhouse to extract an apology from a boy who had insulted Jackson's sister. Parks clicked away with his camera as a youth who mumbled, "I'm sorry," sweat trickling down his face. With a flick of the blade, Jackson lightly lanced the skin on the boy's chest, then knocked him down with his fist.

A few weeks later, after one of the Nomads had been beaten to death by a rival gang, Parks accompanied Jackson and his fellow gang members to the funeral home. As they left the building, the other gang began to chase after them. Jackson and Parks ducked into an abandoned building. Angry at having run away, Jackson went to a window, holding a .45 automatic in his hand, and defied the other gang to

come for him. As Jackson stood there, Parks shot an impromptu portrait of him, which the photographer later called "Harlem Gang Leader." It became one of his best-known works.

Indeed, the assignment of shooting a Harlem gang leader earned Parks not only praise but an offer from Wilson Hicks to join *Life*'s staff permanently. Parks turned Hicks down, however, telling the picture editor his salary offer was too low; on the verge of having his dream of working for *Life* come true, Parks remained determined not to settle for less than what he thought he deserved. Instead, he accepted a freelance assignment from Sally Kirkland. He would accompany her to Paris for a fashion shoot.

Salary negotiations with *Life* continued by telegraph as Parks and Kirkland sailed toward Europe aboard the *Queen Mary*. Parks rejected every offer Hicks made, insisting that he must have a base salary of $15,000 a year. Finally, as the French coastline came into sight, Parks received a final cable from Hicks: "You are mule-headed. $15,000. Congratulations and welcome to the staff."

During the next year, Parks handled an array of assignments for the magazine. Then, in 1950, he was assigned to *Life*'s Paris bureau for two years. The Parkses packed up their belongings, found someone to rent their house in New York, and sailed off to France. Everyone in the family was thrilled by the prospect of living abroad except his wife, Sally, who did not want to leave her friends and move to a foreign land. Once the family was squared away in a spacious house on the outskirts of Paris, however, she too seemed to be excited by the change.

Parks found life in France refreshingly free of racial prejudice. He and his family could travel throughout the nation without difficulty, eating and rooming wherever they wanted without fear of being refused service because of their skin color. In France, Parks

Parks shot this spectacular 1949 fashion picture while he was on a Life assignment in Paris, a city he came to love. His wife, recalled Parks, "didn't particularly dig Paris," but he felt at home immediately. "There was no color problem there," he said. "The atmosphere was good in France."

met composer and conductor Dean Dixon, a noted black American expatriate, and resumed his acquaintance with another self-proclaimed exile from the United States, author Richard Wright. A warm friendship developed between Parks and Wright in Paris. The photographer also befriended boxing champion Sugar Ray Robinson during his stay in Europe.

Several months before his two-year tour in Paris was scheduled to end, Parks received a notice that he was to return to New York. He was puzzled by this message, until he found out some time later that one of Life's editors had taken Sally Parks to lunch and had discovered how unhappy she was in France; the editor felt that by bringing the photographer and his family back to the United States, he might be saving the Parkses' marriage.

Parks's return to America coincided with the early years of the civil rights movement. As blacks began to agitate for equal rights and to fight to end all forms of racial discrimination, Life often sent Parks to document the growing unrest. On one occasion, when a white reporter assigned to cover a story at the Metropolitan Baptist Church in Chicago decided to bow out of his assignment, Parks earned not only the photo credits for the piece but a byline as well. By the early 1960s, he was writing many of the articles and essays that accompanied his photos—something few photographers were allowed to do.

During this period, Parks continued to compose music, and in 1955, Dean Dixon conducted the premiere of Parks's first piano concerto. The recital was held in Venice, Italy, with Dixon's wife, Vivian Rifkin, at the piano. When she played the last note of the concerto and the audience burst into applause, Parks, who was in attendance, could only marvel at how far he had come in his life, from the prairies of Fort Scott, Kansas, to the spotlight of a Venetian concert hall.

But not everything was working out in Parks's life. Since their return from Paris, he and Sally had become increasingly distant from one another. As Gordon, Jr., was leaving for the army in May 1957, he told his father that all three of the children felt that their parents should consider getting a divorce. A few months later, after 20 years of marriage, Parks and his wife once again parted.

Parks continued to handle a variety of assignments for *Life* as the 1960s began. Throughout this tumultuous decade, he strove to remain, he said, "an objective reporter with a subjective heart." One of the most important stories he covered was on the

Preparing to record Parks's piano concerto in a New York City studio are conductor Joe Eger (left foreground), musician Vivian Rifkin (seated at the piano), and the composer himself. Always intrigued by music, Parks had turned professional at the age of 16, when he earned $2 a night for playing the piano in a Minneapolis bordello.

Nation of Islam, a religious movement that promoted black separatism. It was largely because Malcolm X, the dynamic spokesman for the Nation (whose members are known as Black Muslims), came to trust Parks that he allowed *Life* to do a story on the movement. "Success among whites never made Parks lose touch with black reality," Malcolm X said later.

Other people whom Parks photographed were black activists Stokely Carmichael and Eldridge Cleaver, future heavyweight champion Muhammad Ali, and civil rights leader Martin Luther King, Jr. In addition, Parks covered the highly explosive issue of racial segregation in the South and wrote and pho-

tographed a sensitive story on a poor black family in Harlem. The American Society of Magazine Photographers voted him Photographer of the Year in 1960.

In 1961, *Life* sent Parks to Brazil to document life in the slums of Rio de Janeiro. There he befriended an extremely poor young boy named Flavio, who suffered from severe asthma attacks. After Parks's photo essay on Flavio and his family appeared in print, donations from the magazine's readers poured

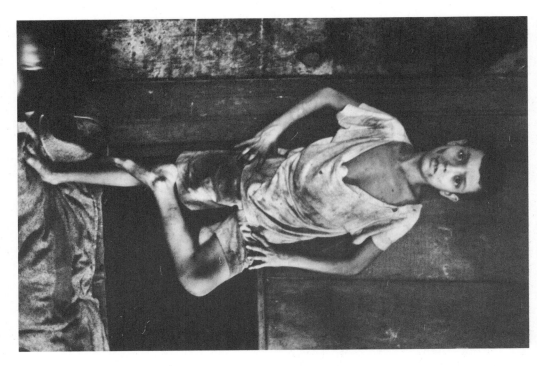

Parks, who took this portrait of a young Brazilian slum dweller in 1961, found himself deeply moved by the boy's plight. "At 12," he said, "[Flavio] was already old with worry. In the tormented, closed world of the shack, assailed by the needs and complaints of his sisters and brothers who were always a little hungry, he fought a losing battle against savagery and disorder."

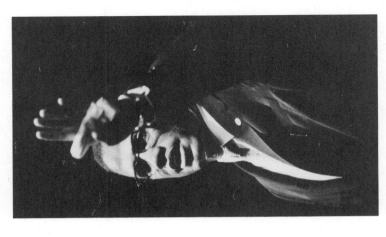

Malcolm X addresses Nation of Islam followers in this Parks photograph from the early 1960s. Suspended by the Black Muslim movement in 1963 for his radical antiwhite views, Malcolm X later endorsed cooperation among the races.

in. When a clinic in Colorado offered to treat Flavio free of charge, Parks arranged for the young Brazilian to come to the United States, where his asthma was successfully treated. In 1978, Parks published his experiences with the youth in a book entitled *Flavio.*

As involved as he was in the social and political issues of his day, Parks also covered stories for *Life* that were in a lighter vein. In 1960, he went on the road with his longtime musical hero, bandleader and composer Duke Ellington, who for Parks had always been the epitome of style and grace. Parks also photographed pieces on subjects as varied as school science fairs, clinics for chronic headache sufferers, and the aftermath of a hurricane. In one of its issues, *Life* ran a feature in which Parks illustrated lines from his favorite American poets with his own photographs.

As he grew more confident of his skill as a writer, Parks began to toy with the idea of writing a book. On New Year's Day, 1962, at the suggestion of *Life* photographer Carl Mydans, Parks wrote down seven pages' worth of his childhood memories. After reading them, Mydans asked Parks if he could show them to a friend. To Parks's surprise, Mydans's friend turned out to be Evan Thomas, executive vice-president of Harper & Row, Publishers.

A few days later, Thomas invited Parks to lunch and offered him $7,000 to write a book based on his 7 pages of memories. Over the course of the next year, Parks worked on an autobiographical novel that he published in 1963 as *The Learning Tree.* Parks's story about growing up black in a small Kansas town attracted widespread attention and added to his already impressive list of accomplishments. In the years since it was first published, *The Learning Tree* has remained an important work of black literature and is widely read in many schoolrooms. ❧

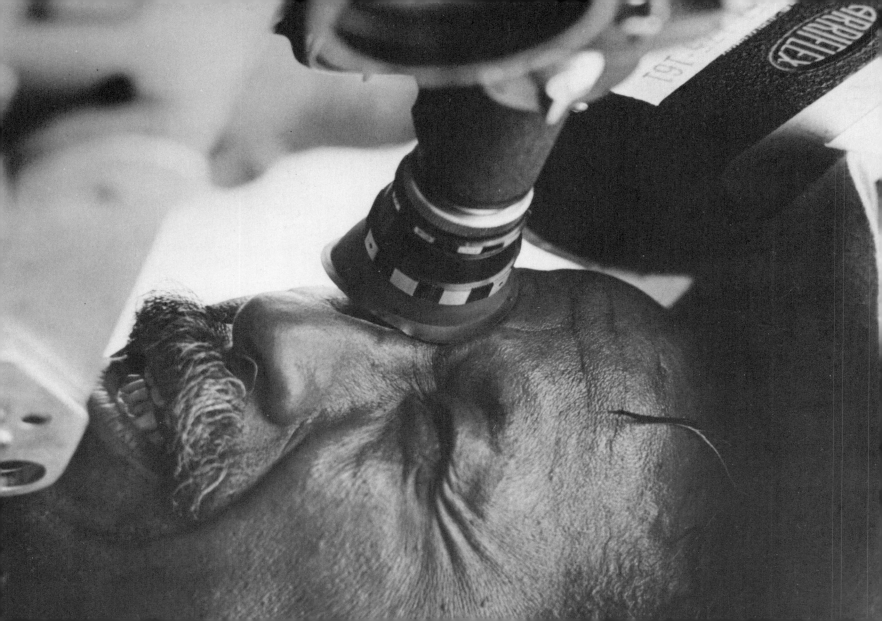

8

MASTER OF
THE ARTS

I N THE MIDST of writing *The Learning Tree*, Gordon Parks met Elizabeth Ann Campbell, the daughter of two of his friends in Switzerland. He was smitten by her beauty and charm, and it did not take long for a romance to develop. The couple wed in 1963, after several months of courtship.

Parks then turned to another writing project. In 1966, the first volume of his autobiography, *A Choice of Weapons*, was published. The second volume, *To Smile in Autumn*, was printed in 1979; another installment, *Voices in the Mirror*, was published in 1990. Among the other books that he has written are *Born Black* (1971), a collection of essays; *Whispers of Intimate Things* (1971); *In Love* (1971); *Moments Without Proper Names* (1975); *Flavio* (1978); and *Shannon* (1981), a novel.

In 1967, Elizabeth Parks told her husband she was pregnant; he received the news with mixed emotions. He loved his 3 children dearly, but at the age of 54, was he ready for another baby? On November 24, 1967, he knew the answer: Parks looked into the shining eyes of his new daughter, Leslie Campbell Parks, and fell in love all over again.

Film director Parks checks out a camera angle for The Learning Tree. The first black to direct a major American movie, Parks exulted in riding "that big camera crane in Hollywood—the crane that had, for so long, been reserved for whites." Now, he said, he "hoped that other black men would take its long ride into the air."

Leslie's birth was not the only event that would delight Parks that fall. For two years, he had been worrying about his son David, serving in the army in Vietnam. At his father's suggestion, David had been writing and mailing home a journal of his experiences in the jungles of Southeast Asia. Parks was proud of the young man's clear, incisive prose, but it was no match for the words he wrote in September: "I'm coming home."

Parks rejoiced. With "a gorgeous, fat, roly-poly baby with soft brown skin and big, inquisitive black eyes," he wrote later, "and my youngest son back from the war, it seemed I had every reason to be happy."

Earlier that year, Parks had traveled through Asia, Africa, and Europe, photographing food markets and restaurants for *Life* magazine. In Cairo, he had found

Gordon Parks and Elizabeth Ann Campbell head for their 1963 wedding in White Plains, New York. Divorced from Sally, his wife of 20 years, in 1957, Parks proposed to Campbell a few months after their first meeting. The couple would become parents of a daughter, Leslie Campbell Parks, in 1967.

himself with a little time to kill and, on a whim, had visited a fortune-teller. The Egyptian seer told him that the following year would present many challenges, calling for all of Parks's talents. Parks put little stock in such prophecies, but as 1967 neared its end, he could not help wondering if there was something special in the wind.

The year 1968 was indeed special, but as it turned out, most of its events were tragic. In April, civil rights leader Martin Luther King, Jr., was assassinated in Memphis, Tennessee. Two months later, Senator Robert F. Kennedy fell to the bullets of another assassin, in Los Angeles. In August, massive street demonstrations disrupted the Democratic Convention in Chicago; for the rest of the year, riots, antiwar demonstrations, and clashes between police and militant black groups dominated the news.

Life assigned Parks to cover King's funeral; shocked and grief stricken like most Americans, he flew to Atlanta to witness the fallen hero's last rites. On the plane back to New York City, he wrote an essay for *Life* about King. Parks was determined to state the truth about being black in America, regardless of the discomfort some readers might have felt at his words. King's message of brotherhood echoed in Parks's mind as he wrote:

[King's] only armor was truth and love. Now that he lies dead from a lower law, we begin to wonder if love is enough. Racism still smoulder and the fires still engulfs us. The extremists, black and white, are buying the guns. Everywhere—Army troops stand ready. Our president is warned against going to Atlanta. America is indeed in a state of shock. The white man, stricken, must stay firm in his conscience, and the black man must see that he does. If the death of this great man does not unite us, we are committing ourselves to suicide. If his lessons are not absorbed by the whites, by Congress, by my black brothers, by any who would use violence to dishonor his memory, that "dream" he had could vanish into a nightmare. You and I can fulfill his dream by observing his higher law of nonviolence to the echo of his drumbeat.

Unfortunately, not everyone chose to honor King by refraining from violence. His murder led to riots in 125 cities; despite the intervention of 55,000 federal troops, 46 people died and 21,270 were arrested. The tragedy did have one positive result: Spurred into action by the nation's outrage over King's assassination, Congress passed the Civil Rights Act of 1968, a law that prohibited racial discrimination in housing.

The year 1968 provided Parks with a full measure of anger and sorrow. But, as the fortune-teller had promised, it also offered him new opportunities. It was during this year that he resigned as a *Life* staff photographer. After almost a quarter century, Parks left the magazine to try his hand at filmmaking.

Soon after publication of *The Learning Tree*, Parks and two colleagues at Time, Inc. (publisher of *Time* and *Life* magazines) had tried to sell the story to Hollywood. Several studios expressed interest. One even offered Parks a large sum of money for the autobiographical novel—if he would agree to make its characters white. No studio, however, would agree to the deal laid down by Parks and his associates: If anyone made a film of *The Learning Tree*, Parks would direct it.

Parks had worked as a film consultant since the mid-1950s and had made a trio of short documentaries and a movie for National Educational Television, but he had never been directly involved in the creation of a feature film. Nevertheless, he knew he was the most qualified person to oversee a movie version of his book. It was, after all, a fictionalized version of his own life story.

No major Hollywood studio had ever hired a black director and none wanted to be the first to do so—until actor-director John Cassavetes got involved. Cassavetes, who had read the novel and loved it, approached Parks in the spring of 1968. He said he wanted to see the color barrier in Hollywood come down.

Twenty-four hours after that conversation, Cassavetes called Parks from Hollywood. "Take the first plane out here tomorrow morning and come straight to Warner Brothers–Seven Arts in Burbank," he said. "I'll be waiting for you in Kenny Hyman's office."

"Who's Kenny Hyman?" Parks asked.

"The cat who runs the joint," Cassavetes said.

The next day, Parks walked into Hyman's office. After a brief discussion, Hyman held up a copy of *The Learning Tree*. Was this the book, he asked, that Parks wanted to turn into a movie? When Parks said it was, Hyman asked, "You want to direct it?"

"Yep," Parks said.

"When do you want to start?"

"Right away," Parks replied.

"You wrote the book," Hyman said. "Would you like to write the screenplay?"

By the end of their conversation, Hyman and Parks had arrived at an agreement to film *The Learning Tree* with Parks as both director and screenwriter. In the coming weeks, Hyman was also to ask Parks to become the film's producer and to write the music for its sound track. The two men had suddenly knocked a hole in the wall that had always separated blacks from major positions in the movie business.

Aided by Hyman and executive producer William Conrad, Parks set to work casting the film and assembling a crew. He hired not only a predominantly black cast but employed more blacks for his crew than most Hollywood filmmakers generally did for their movies. Because few blacks had ever been given the chance to learn such arts as lighting, sound, and set design, Parks hired qualified white technicians to help his black team master the tricks of the trade.

When he was ready to start filming *The Learning Tree*, Parks moved his actors and crew to Fort Scott, Kansas. Not all the residents of Parks's hometown were happy to see him. When he asked a local man

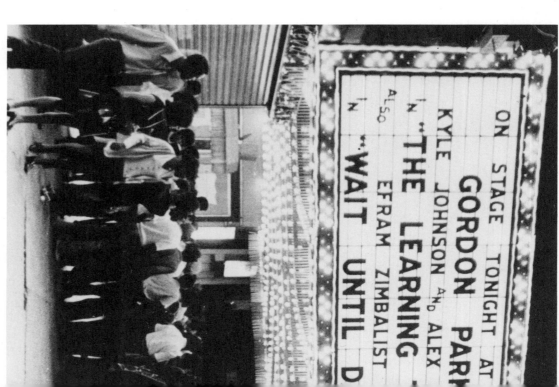

for permission to film on his farm, for example, the reaction was explosive. The farmer not only refused but threatened to shoot any crew member who set foot on his land. "I don't want nothing to do with that dirty, lying book about whites lynching Negro people!" he shouted.

Parks then paid a call on the mayor. The film company, he noted, expected to spend some

Manhattan fans await Gordon Parks's personal appearance at a showing of his 1969 hit film, The Learning Tree. As the movie's writer, director, producer, and sound-track composer, Parks had single-handedly broken Hollywood's decades-old color barrier.

$250,000 in Fort Scott. This information warmed up the atmosphere considerably. Soon afterward, in fact, Fort Scott established a Gordon Parks Day.

The *Learning Tree* opened in August 1969 to mixed notices. Some reviewers praised the film's honesty; others criticized it as "too nostalgic." Militants complained that Parks had not come down hard enough on white racists. In any case, *The Learning*

Tree became in 1989 one of 25 films to be selected for the National Film Registry of the Library of Congress.

Parks himself regarded the film as the truth about his childhood and as an example of what a black director could do when given the chance. The film, he wrote later, was "the resolution of whatever it was that took me from that Kansas cornfield to that big camera crane in Hollywood—the crane that had, for so long, been reserved for whites. Now I hoped that other black men would take its long ride into the air."

Soon after release of *The Learning Tree*, MGM asked Parks to direct *Shaft*, the first film about a black private eye. Under his direction and with Richard Roundtree's performance in the leading role, *Shaft* became an instant blockbuster. "A violent thriller with an all-black cast . . . acceptable to all audiences," said one reviewer. "Features relentlessly supercool dialogue," noted another.

The day after *Shaft's* 1971 Manhattan premiere, David Parks called his father at 3:00 A.M., demanding that he come to the theater at once. Parks arrived at the movie house still half-asleep, but his eyes snapped open when he took in the scene. Snaking around a whole city block in the predawn darkness, a double line of eager New Yorkers waited to buy tickets to the year's newest smash hit, *Shaft*.

The film's success made stars of director Parks and actor Roundtree, who gave blacks a handsome, tough hero they could respect. Ecstatic over *Shaft's* multimillion-dollar ticket sales, MGM executives rushed to do a sequel. This time, they asked Parks both to direct and to write the movie's theme. Released in 1972, *Shaft's Big Score* featured a new hit song, "Don't Misunderstand," and once again starred Richard Roundtree. Despite some critical reservations about the plot ("incomprehensible," said one reviewer),

audiences flocked to see this second "supercool" black thriller.

Parks's next film venture involved the life story of legendary black folksinger Huddie ("Leadbelly") Ledbetter. When Paramount Pictures invited him to direct *Leadbelly*, Parks accepted with pleasure. As the movie neared completion, however, Paramount went through an executive shake-up. The studio's new management, unenthusiastic about a film started by its predecessors, refused to promote it. Despite extremely positive reactions from those who saw the film, Paramount eventually shelved it, a decision that greatly upset Parks. Of all his movies, he was proudest of *Leadbelly*, which was released in 1976.

In 1972, Parks had another reason to be proud: A letter from the NAACP announced that he had been selected as the organization's 57th Spingarn Medalist. Every year since 1915, the NAACP has chosen one black person of special distinction to receive the Spingarn Medal, a gold medallion engraved with the words "For Merit." In addition to Parks, medalists have included author Richard Wright, poet Langston Hughes, educator Mary McLeod Bethune, civil rights leader Martin Luther King, Jr., Supreme Court justice Thurgood Marshall, and singer Marian Anderson.

In his acceptance speech, delivered to a standing-room-only crowd in Detroit, Parks talked about relationships among people, blacks in particular. Acknowledging one another as brothers and sisters, he said, requires more than a shared skin color or a hip handshake; true kinship means acting on behalf of others. The worst racism, he added, was the racism directed at blacks by other blacks. Real bonding means mutual respect, regardless of race.

The audience, which included more than 1,000 young black men sitting together as a block, applauded and chanted, "Brother! Brother!" Parks later

Parks attends a reception with Genevieve ("Gene") Young, the Manhattan editor who became his third wife in 1973. Although this marriage would also end in divorce—the couple parted in 1977—Parks and Young remained close friends.

recalled waving from the stage, hoping his message had got through. He had tried to share the most important lesson he had ever learned: that hatred is self-destructive, that people must rely on one another if they want to improve their society.

Soon after his Detroit speech, Parks faced another turning point in his life. He and his wife, Elizabeth, had been finding themselves increasingly at odds. Although they would remain good friends, they obtained a divorce in early 1973. The following August, Parks married Genevieve ("Gene") Young, a Chinese-American editor at Harper & Row, Publishers.

By Chinese tradition, Parks's marriage to Young automatically made him an "uncle" to the children of his wife's family; they affectionately nicknamed

Parks and his daughter Leslie share a quiet moment in his Manhattan residence. The apartment's library includes an impressive stack of books written by Parks himself.

him Kao Teng Pai, or "high achiever." The youngsters liked Parks, but the interracial marriage gave them some minor problems: When one boy identified a photograph of Parks as his "Uncle Gordon," for example, his teacher said he had made a mistake. After another nephew's similar experience, Parks gave his new young relatives pictures inscribed, "From your Uncle Gordon, better known to you as Kao Teng Pai." That ended that problem. But there were to be others.

The highly efficient Young quickly took charge of organizing her husband's life. Parks, who had never paid much attention to keeping track of appointments, paying bills on time, or balancing checkbooks, appreciated his wife's careful attention to detail. Nevertheless, the couple's differences began to create friction between them.

Parks and Young kept frantically busy in their respective professional lives; in the early 1970s, Young edited several best-selling books while Parks made movies, composed music, and worked on several books of his own. The combination of dissimilar goals and highly pressured working schedules finally took their toll, and in 1977, the couple agreed to a divorce.

Parks moved into a spacious modern apartment with splendid views of the United Nations and Manhattan's East River. From this base, he continued to wield the creative tools he had chosen long before. During the 1980s, he contributed articles and photographs to *Life* and wrote several books. He also directed a film for "American Playhouse" and composed the music for a ballet based on the life of Martin Luther King, Jr.

At this point in his life, Parks had acquired a host of admirers. Not everyone, however, considered him a hero. Religious fundamentalist Jerry Falwell, for example, made it clear that he considered some of

Parks's work, notably *The Learning Tree*, unsuitable for young readers. In their efforts to ban *The Learning Tree* from schools, Falwell and his allies brought several lawsuits; one such suit reached the United States Supreme Court, which dismissed the case without comment.

The book-banning attempts failed to bother Parks. "Every time there was a lawsuit, there was publicity, and my publishers would print another 15,000 copies," he once commented. Then he added with a smile, "Sometimes, I wish Falwell had tried to ban my other books."

By 1988, even the White House had taken notice of Parks and his remarkable achievements. That year, on a hot, steamy August afternoon, the 75-year-old Parks strode into the East Room to accept the National Medal of Arts from President Ronald Reagan. Along with 12 others, including author Saul Bellow, actress Helen Hayes, and architect I. M. Pei, Parks was honored for his outstanding contribution to the cultural life of America.

When Parks received his medal from the president, the White House press corps stood up and cheered—an unusual tribute from a group not known for its sentimentality. The photographers and journalists were acknowledging their debt to a man who had set the standards for those who followed him.

Asked to comment after the awards ceremony, Parks said simply, "It's been a long journey." He was speaking not only of the hundreds of thousands of actual miles he had traveled. He was also referring to the distance he had covered in his efforts to use his talents as a photographer, a writer, a composer, a filmmaker, and recently, a painter. The young Kansan who once determined to make something of himself had indeed covered a lot of ground.

In another sense, Parks was talking about the distance America had come in his lifetime. The first

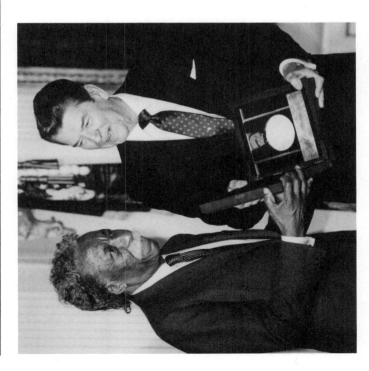

In an August 1988 ceremony at the White House, Parks accepts the National Medal of Arts from President Ronald Reagan. Although he never received a high school diploma, Parks eventually earned 24 honorary doctorates from colleges and universities across the nation.

time he visited Washington, D.C., more than 40 years earlier, he had been denied a seat at lunch counters, turned away from movie theaters, and refused service in department stores. In 1988, although he might still encounter some forms of bigotry, he was free to go wherever he pleased in his nation's capital.

In battling the effects of prejudice—limited opportunities, poverty, and brutality—Parks learned not only how to channel his anger but how to make the best use of his multiple talents. He put all he had into everything he did, from waiting on tables to composing music, from photographing fashions to directing films. In the process, he demonstrated how much one determined man could achieve.

"Don't ever give me your color as a cause for failing," his mother had told him. Parks heeded her words. Refusing to bow to racial prejudice or poverty, he made himself a legendary photographer, a best-

Parks (seen here working on Leadbelly in Texas) showed no signs of slowing down as the years passed. As the celebrated photographer approached his 78th birthday, he was writing a new novel, arranging a Manhattan exhibit of his oil paintings, and planning a film shoot in the Soviet Union.

selling author, and a highly respected composer. Ignoring convention, demanding his rights as a free man, smashing through whatever obstacles society put in his way, Parks blazed his own trail. His story can help young people—of both sexes and all races—realize that their good fortune can depend on the quality of their courage.

Turning 78 years old in 1990, Parks continued to receive his fair share of awards. On April 23, he accepted the Lifetime Achievement Award from the International Center of Photography. Later in the spring, he picked up his 24th honorary doctorate.

In 1990, Parks was also doing what he had always done: working on several ambitious projects at the same time. They included writing a historical novel about 19th-century British painter J. M. W. Turner; preparing to make a film in the Soviet Union about the black Russian poet Aleksandr Pushkin; completing an assortment of musical compositions; and making arrangements for an exhibit of his oil paintings at a Manhattan art gallery.

When an interviewer asked Parks why he continued to work at such a breakneck pace, the silver-haired artist smiled. Then he pointed to the photographs of his parents, simply framed and nestled among the paintings, medals, fan mail, and stacks of books that crowded his apartment. "I like to think they know," he said softly, "that I've tried to make something of myself." ✸

CHRONOLOGY

1912 Born Gordon Alexander Parks on November 30 in Fort Scott, Kansas

1928 Moves to St. Paul, Minnesota

1932 Parks's song "No Love" is performed on national radio by Larry Duncan's orchestra

1933 Parks marries Sally Alvis

1934 Son Gordon, Jr., is born

1937 Parks buys his first camera

1938 Joins a semiprofessional basketball team

1940 Daughter Toni is born

1941 Parks receives a fellowship from the Julius Rosenwald Fund

1942 Begins working for Roy Stryker at the photographic division of the Farm Security Administration

1944 Works as a photographer for Standard Oil; son David is born

1947 *Flash Photography* is published

1948 *Camera Portraits* is published

1949 Parks becomes the first black photographer on the staff of *Life* magazine

1955 Parks's first piano concerto is given its premiere performance

1960 Parks is selected Photographer of the Year by the American Society of Magazine Photographers

1963 Marries Elizabeth Campbell; *The Learning Tree* is published

1966 *A Choice of Weapons* is published

1967 Parks's daughter Leslie is born

1968 Parks produces, directs, writes, and composes the score for the screen version of *The Learning Tree*

1971 Directs the hit movie *Shaft*; *Born Black*, *Whispers of Intimate Things*, and *In Love* are published

1972 Parks is awarded the NAACP's Spingarn Medal; directs *Shaft's Big Score*

1973 Marries Genevieve Young

1975 Directs *Leadbelly*; *Moments Without Proper Names* is published

1978 *Flavio* is published

1979 *To Smile in Autumn* is published

1981 *Shannon* is published

1986 Parks is chosen Kansan of the Year

1988 Awarded the National Medal of Arts

1989 *The Learning Tree* becomes one of 25 films selected for the National Film Registry of the Library of Congress

1990 Parks receives the Lifetime Achievement Award from the International Center of Photography; *Voices in the Mirror* is published

FURTHER READING

Bush, Martin H. *The Photographs of Gordon Parks*. Wichita, KS: Edwin A. Ulrich Museum of Art, Wichita State University, 1983.

Danska, Herbert. *Gordon Parks*. New York: Crowell, 1971.

Parks, Gordon. *Born Black*. Philadelphia: Lippincott, 1971.

——. *A Choice of Weapons*. New York: Harper & Row, 1966.

——. *Flavio*. New York: Norton, 1978.

——. *The Learning Tree*. New York: Harper & Row, 1963.

——. *Moments Without Proper Names*. New York: Viking, 1975.

——. *Shannon*. Boston: Little, Brown, 1981.

——. *To Smile in Autumn*. New York: Norton, 1979.

——. *Voices in the Mirror*. New York: Doubleday, 1990.

——. *Whispers of Intimate Things*. New York: Viking, 1971.

Rothstein, Arthur, et al. *A Vision Shared: The Words and Pictures of the FSA Photographers, 1935–1943*. New York: St. Martin's Press, 1976.

Stryker, Roy, and Nancy Wood. *In This Land: America, 1935–1943, as Seen in the Farm Security Administration Photographs*. Boston: New York Graphic Society, 1973.

INDEX

PICTURE CREDITS

AP/Wide World Photos, p. 103; From the Collection of J. K. Graham, Fort Scott, Kansas, pp. 24–25; From the Collection of the Minnesota Historical Society, pp. 36–37, 47; Photo by Jack Delano, courtesy of Library of Congress, p. 57; Photo by the *Fort Scott Tribune*, pp. 28–29; Photo by Dorothea Lange, courtesy of Library of Congress, p. 55; New York Public Library, Schomburg Center for Research in Black Culture, pp. 10 (Morgan Smith), 51; Photo by Herbert Nipson, South Side Community Art Center, Chicago, Illinois, p. 64; Photo by Gordon Parks, pp. 16, 44, 60, 80–81, 84, 88, 89; Photo by Gordon Parks, courtesy of Library of Congress, pp. 15, 18, 73; Photo by Gordon Parks, Photographic Archives, University of Louisville, pp. 70, 74; Photo by Toni Parks Parsons, 106; From the Private Collection of Gordon Parks, frontispieces, pp. 20–21, 23, 32–33, 41, 42, 63, 66, 68, 78, 86–87, 90–91, 92, 96–97, 100, 101 (Henry Grossman), 104

SKIP BERRY is a free-lance writer whose articles have appeared in the *New York Times*, *Travel & Leisure*, *USAIR Magazine*, *Spirit*, the *Chicago Tribune*, *Midwest Living*, *Sport*, *Home*, and dozens of other periodicals. He lives in Indianapolis, Indiana, where he enjoys bicycling, movies, and music.

NATHAN IRVIN HUGGINS is W.E.B. Du Bois Professor of History and Director of the W.E.B. Du Bois Institute for Afro-American Research at Harvard University. He previously taught at Columbia University. Professor Huggins is the author of numerous books, including *Black Odyssey: The Afro-American Ordeal in Slavery*, *The Harlem Renaissance*, and *Slave and Citizen: The Life of Frederick Douglass*.